# BEV DOOLITTLE
## New Magic

To Pam & Roy,

Thanks for all your help
at the show

Bev Doolittle

3·27·96

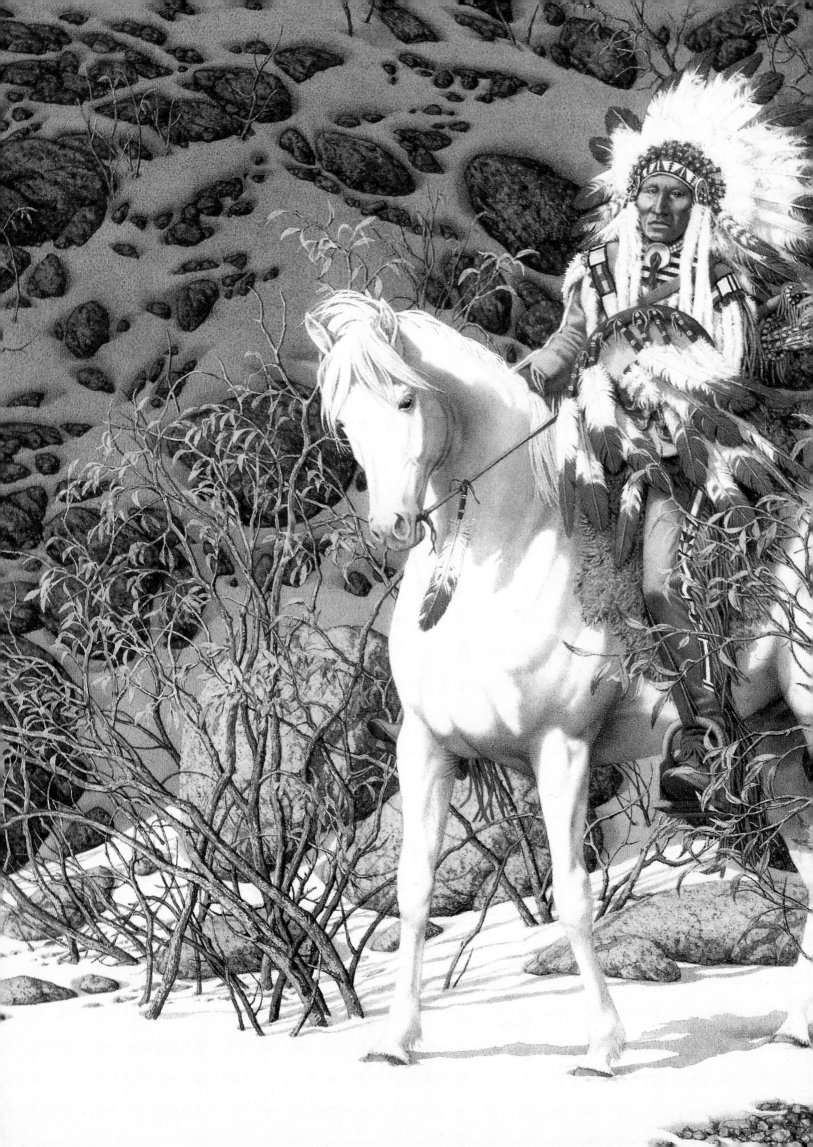

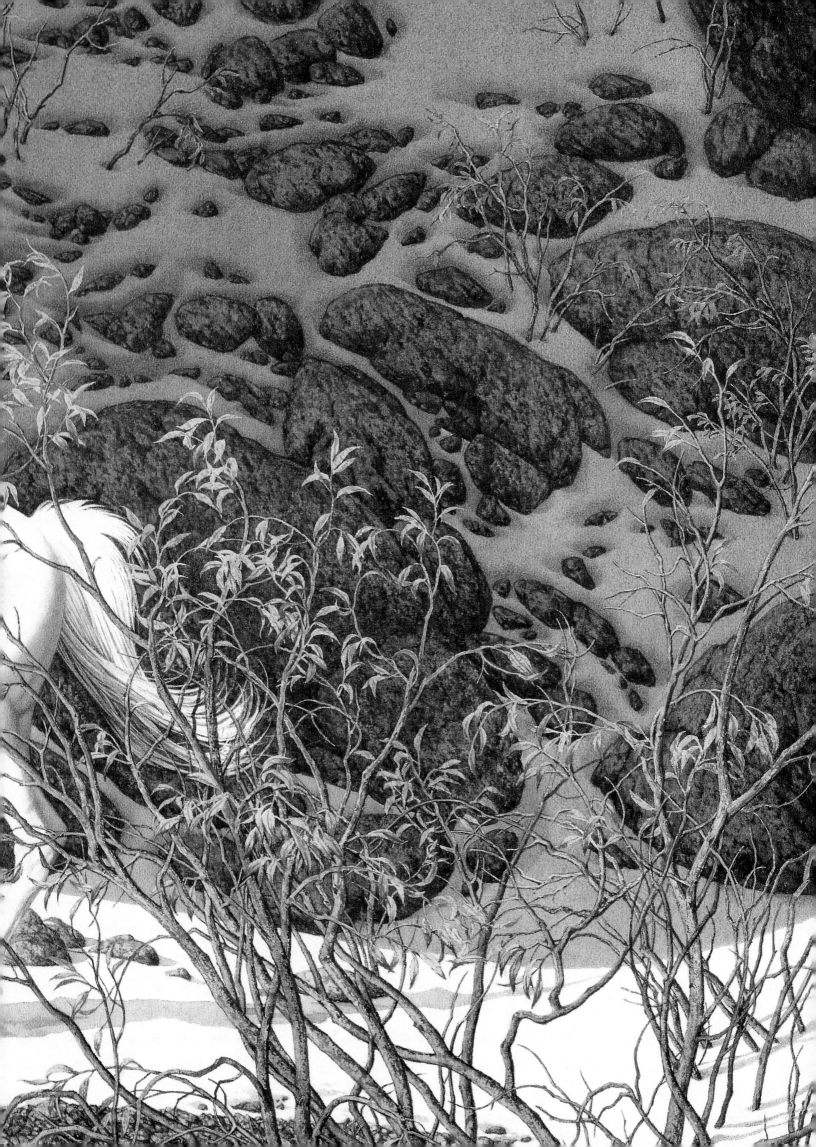

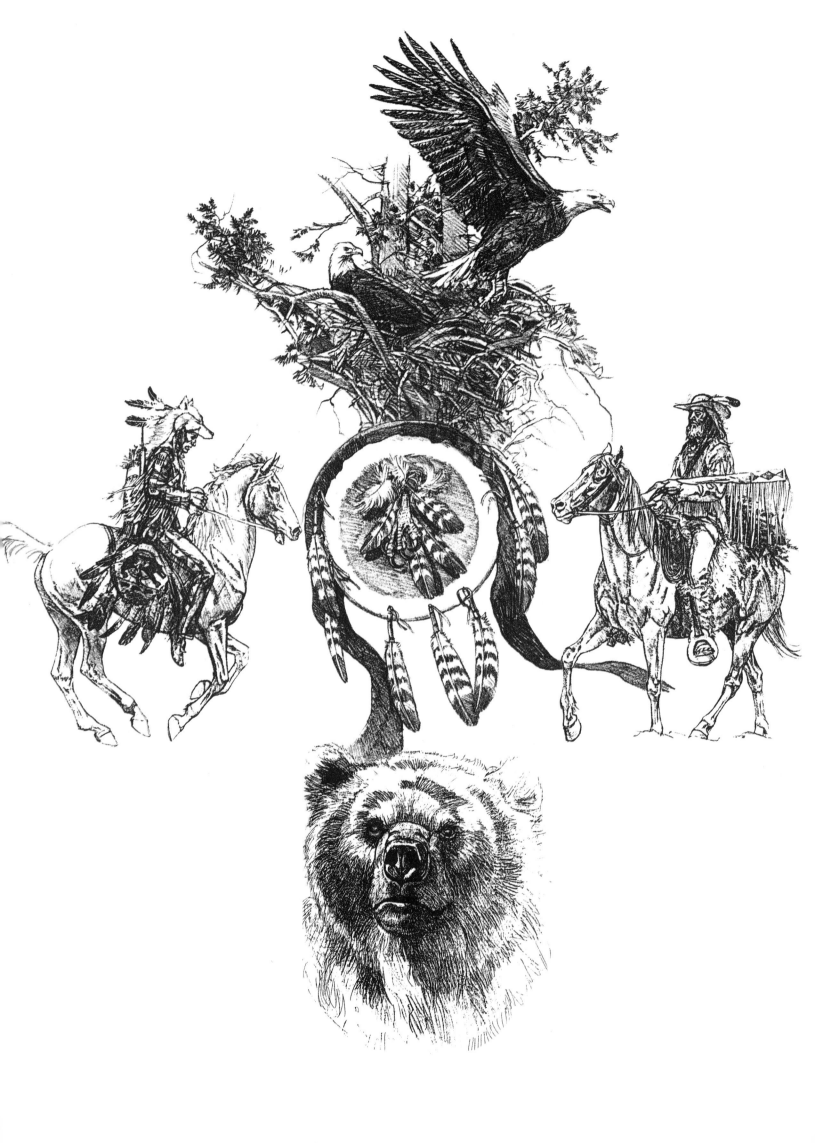

# BEV DOOLITTLE
## New Magic

### Text and Poems by
### Elise Maclay

THE GREENWICH WORKSHOP

*Thanks to Dave Usher and all my friends*
*at The Greenwich Workshop for believing in me*

A GREENWICH WORKSHOP™ BOOK

Copyright © 1995 The Greenwich Workshop, Inc.

For information contact: The Greenwich Workshop, Inc.
One Greenwich Place, Shelton, Connecticut 06484

LIBRARY OF CONGRESS CATALOGING-IN-PUBLICATION DATA
Maclay, Elise.
Bev Doolittle: new magic/text and poems by Elise Maclay. — 1st ed.   p. cm.
ISBN 0-86713-026-1 (acid-free paper)   1. Doolittle, Bev—Criticism and interpretation.
2. Nature (Aesthetics)  I. Doolittle, Bev.  II. Title.
ND237.D623M33   1995   759. 13—dc20   95-15256 CIP

Published simultaneously in the United States and Canada
Book design by Peter Landa
Display face, Wolftrack, designed by Philip Bouwsma
Printed in Italy by Amilcare Pizzi, S.p.A.
First Edition

95 96 97 0 9 8 7 6 5 4 3 2

FRONTIS ART:
2–3, detail from *Walk Softly*
4–5, detail from *Eagle Heart*

# CONTENTS

# AUTHOR'S FOREWORD

I have known Bev Doolittle for almost a decade. Reading that, I have to laugh. If Bev read it, I know she'd say, "A decade sounds better than ten years, huh?"

Praised and prized by critics and collectors, her every print a best-seller, mobbed at signings, loaded down with honors and awards, Bev's still Bev. If the emperor has no clothes, she'll be the first to notice it. But she'll kid him about it and laugh with him, not at him.

Love, not ridicule; painting, not protest is Bev Doolittle's modus operandi. Concerned about endangered species and wildlife habitats, she leaves hand-wringing and exhortation to others and creates beautiful paintings with significant messages embedded within them. Her paintings are joyous and uplifting. She paints the wild, gorgeous world of nature the way she sees it—with love and appreciation—and draws her audience in to celebrate with her the wonder of the wild.

She has been doing this in amazingly varied ways since childhood. And each painting is the outgrowth of personal experience—a walk in the high desert where she lives, a canoe trip in the

Alaskan wilderness, sleeping out under the stars in the Canadian Rockies. The story is told in *The Art of Bev Doolittle*, published in 1990. A book that proved to Bev and me that this was something we both liked to do especially if we could sneak in a hike or two.

*N*ew Magic begins where *The Art of Bev Doolittle* left off—at the start of a new and exciting period in Bev Doolittle's life and art. Somewhere between the first book and the second, at the height of her artistic powers, Bev Doolittle had a kind of vision, almost literally saw her mission and began to paint it. Suddenly she found herself going down new paths, meeting new people, exploring new ideas, finding adventure not only in the wilderness but in the public arena. At the same time, her paintings began to take on a more public, more powerful role. They continued to delight and inspire but they also raised hundreds of thousands of dollars for wilderness conservation, education and wildlife causes.

The only person who is not surprised by any of this is Bev Doolittle. Magic is her element.

—Elise Maclay, 1995

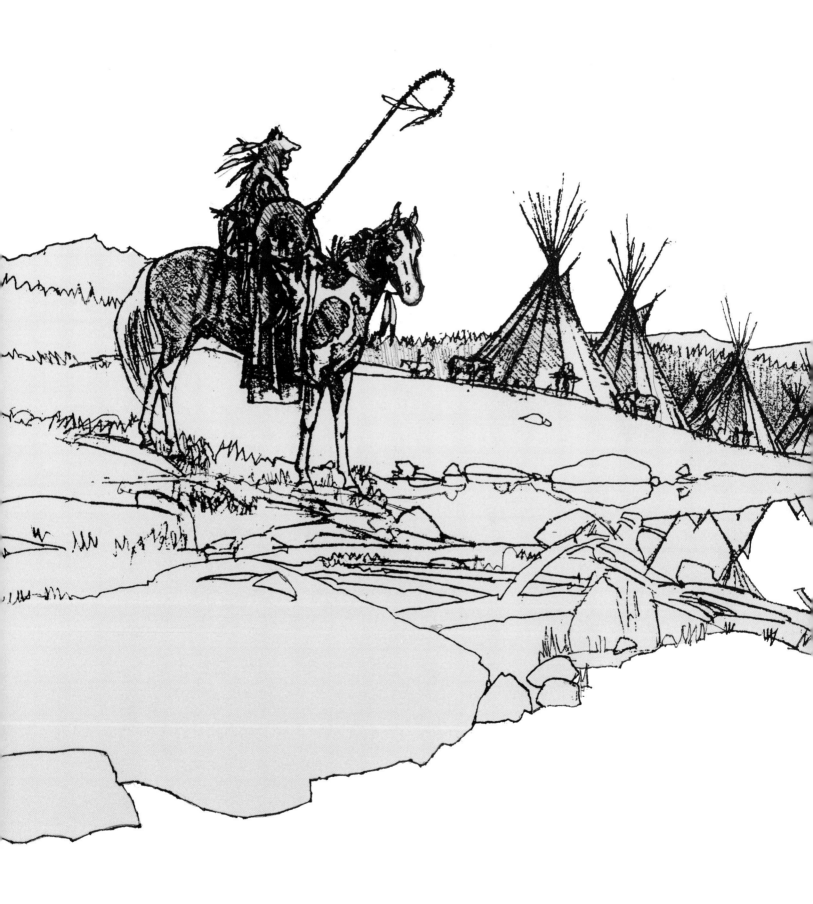

# 1
## The Art of Living

# 1

# The Art of Living

At the airport, she is met by her husband and son and together they drive away from the city, across the desert floor and up into the dry, wild canyon country beyond. Sand blows across the road. Bunchgrass glows in the afternoon sun and dagger-leafed Joshua trees raise their spiky arms in mysterious supplication, casting long, twisted shadows. Huge, rounded boulders, piled as if by the hand of God, form monumental pyramids and domes. The light is clearer than glass. The sky is cloudless and immense, a limitless gift of space.

To Bev Doolittle this is the most beautiful place on earth. A place where silence collects in hollows and there is room for every living thing to live and grow in its own unique way, not crowded and bent into something it was not meant to be. The high desert, wild and free. Home.

As always when she returns after having been away for a while, the harsh beauty of the place makes her catch her breath. She wants to jump out of the car and see it the only way it can be seen. On foot. Up close. For there are secrets here, mysteries, worlds within worlds, seen and unseen inhabitants—coyote, black-tailed jackrabbit, collared lizards, piñon mice, white-throated swifts, rock wrens and Gambel's quail, and elusive as the night wind, gray fox and bobcat.

There is time and a reason for a hike before the sun sets. The Doolittles are building a new house and Jay and Jayson are eager to show Bev what has been accomplished in her absence. If looking at a house under construction doesn't sound like a nature walk, it's because few houses are located on ten boulder-strewn acres abutting the country's newest national park. And few houses are like this

one. It would not be stretching a point to say that none are—unless you count the nests and lairs wild things call home.

Like one of Bev Doolittle's camouflage paintings, her new house is almost indistinguishable from the towering rock formation that is its site. This is more than an optical illusion. House and earth flow into each other to form an organic whole. Sheets of glass invite the sky in. Natural rock walls form rooms and halls. But to speak of rooms and halls is to miss the point. This is not a conventional house. It is a series of places to live and be and do. For the Doolittles, living and being and doing are aspects of their primary focus: art. So first priority is given to a spacious art studio with his and her drawing boards, desks and supply areas companionably adjacent. "We've always worked together," Bev says. "We like to."

She explains that more often than not, she and her husband are working on different projects, but they like having each other near for consultation—or "to talk to when we remember something wonderful or think of something funny." Before the house was designed, she told the architect, "Privacy is very important to me—but it doesn't extend to Jay or Jayson. My family are not distractions; they're part of me and I work better when they're around."

With space set aside for art, the architect was encouraged to let his imagination soar. So there is a sort of dais with skylights for sleeping, a firelit grotto and an east-facing niche for eating. There are all manner of eagle perches for viewing the majesty of a desert preserve that extends for hundreds of thousands of acres and reaches back, untouched, to the beginning of time. There is also

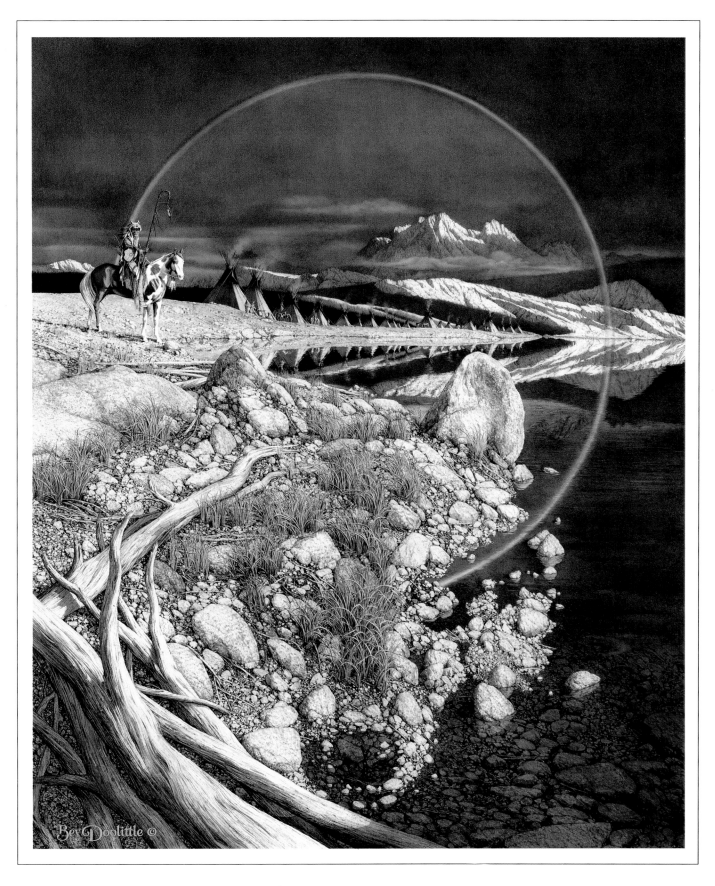

# THE SENTINEL

a terrace for watching sunsets, a rock-bound pool to swim in and, below it, connected by a waterfall, a small reflecting pool to share, in silence, with shy desert creatures that may come to drink.

Designed by Kendrick Bangs Kellogg, who works in the tradition of Frank Lloyd Wright, the house is at once solid and soaring. A sheltering cave with lofty pillars and airy arches like the ones that the wind carves from desert rock. Constructing it is an affair of the heart. Practicing the ecological lifestyle she preaches, Bev Doolittle insists that the earth be treated gently. Heavy equipment is used only when absolutely necessary. Excavation is done mostly by hand and material is hauled in and out by wheelbarrow. Construction defers to wildlife. Once a pair of roadrunners decided to build a nest in the structural steel of one of the supporting columns. Oblivious to the activity around them, the birds finished their nest, the female laid eggs and the baby birds hatched with the work crew as interested godparents. When it came time to pour concrete into the pillar, the birds were not ready to move out. So, Jay Doolittle says, "we had to skip their column until they decided to leave. We didn't notice until several days later that other birds had started a second nest and family, this time in a patio support. We waited out that family, too."

Jay is at the site almost daily for consultation with the work crew, and Bev comes often. She restores a tiny flower to the rock crevice from which it has fallen. She transplants a bush that is growing where a pillar is to go. She deplores an accidental gouge in a boulder and spends an hour mixing paint, dirt and cement to the right gradation of gray to repair it. Inside and out, natural rock walls are allowed to be what they are, weathered and time-worn, filmed with yellow lichen, draped with coyote melon vine.

"We wanted a house that would be as much as possible like living outdoors," Bev Doolittle says. It does not worry her that such a house has been years in the making. Patience characterizes every-

thing she does—especially painting. Every detail is researched. A sketch may remain on her drawing board for weeks while she revises it again and again until she feels it is just right. She may make a dozen tissue overlays to determine the best arrangement between the play

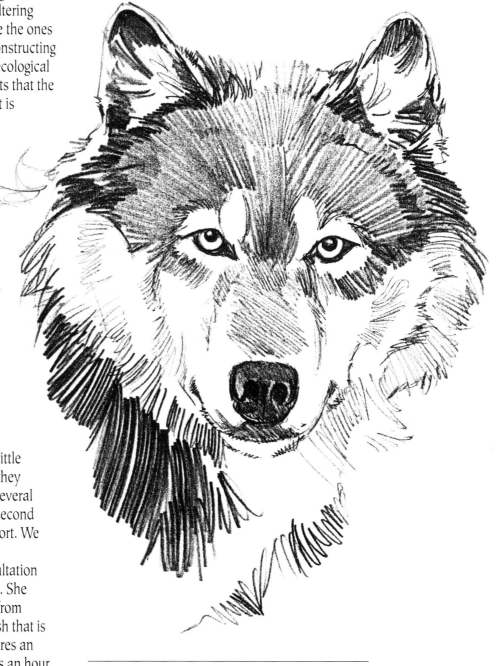

*"A deep chesty bawl echoes from rimrock to rimrock, rolls down the mountain, and fades into the blackness of the night. It is an outburst of wild defiant sorrow and of contempt for all the adversities of the world…. It tingles the spine of all who hear wolves by night, or who scan their tracks by day."* —ALDO LEOPOLD
*A Sand County Almanac*

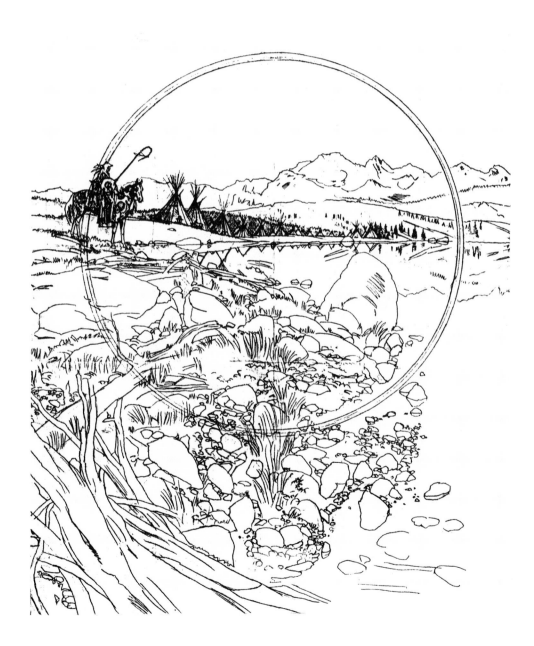

of light and dark. Her style allows for no shortcuts, blurring or fudging. Look at her paintings with a magnifying glass if you wish and you will find that as in nature itself every stone, every blade of grass, every hoof, ear, nostril, paw is fully and perfectly formed. Refusing to be rushed, Bev meets deadlines by putting in more time, rising earlier, working later. She says, "When a painting is finished, no one will care how many hours it took. What matters is how good it is."

She explains that for her creating a painting has two aspects. The first is the most difficult and the most exciting: Getting the idea. There has to be a reason for every painting, a message, an insight. Finding it and finding a way to express it visually is the hard part. After that, her talent and training take over.

Her mother says that Bev seemed to be able to draw from the moment she first picked up a pencil. Art school and practice have honed this natural

ability and taught her principles of composition and design that have by now become second nature to her, undergirding her paintings with an assurance that gives form and focus to their lyrical quality.

There was never the angst of trying to decide between life and art. For her they are one and the same, made all the easier because she married an artist who feels as she does. In the early years Bev and Jay did both advertising and illustration work. Talent allowed them to make a living in fine art. However, they are convinced (and to know them is to be certain) that had it been necessary to continue working in the commercial field, they would have done so as creatively as possible; their artistic muse pursued after-hours, nights, Sundays, whenever. The art, not the reward, was and is their mutual goal.

Now they are managing to fit into their artistic life one son, three cats, incredibly arduous print-signing sessions and a great deal of travel on Bev's part as she appears at shows and galleries and on radio and TV. Shy at first, she is getting better at public appearances and she genuinely enjoys meeting those who love her art. But she misses Jay and Jayson when on the road, and is always eager to get back home.

Until the new house is finished, home is the two-bedroom ranch they repaired to more than ten years ago. A porch has been glassed in and filled with plants. An apartment for Jay's mother has been built on. And an art studio with two drawing boards and a copying machine has been added. Here, on floor-to-ceiling shelves, the books Bev needs and uses when she paints are arranged according to category—Native American culture, national parks, wildflowers, rock paintings, songs and legends, desert survival, design, anatomy—a fabulous collection ranging from scientific tomes to children's books.

In filing cabinets are thousands of references she has clipped and saved because they contain a germ of an idea. Her own photographs, thousands of them in slide form, are meticulously catalogued

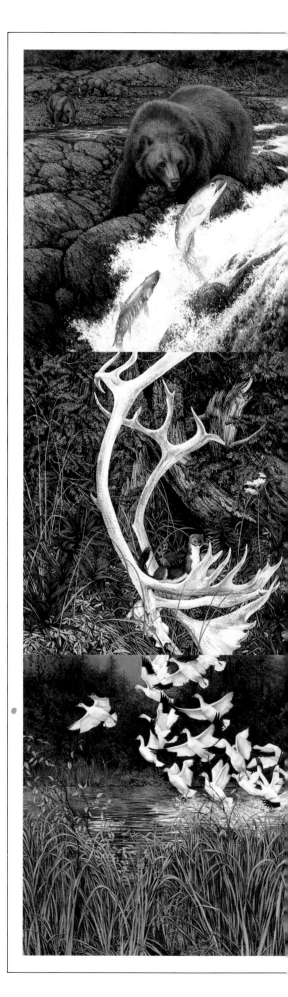

# THE SACRED CIRCLE

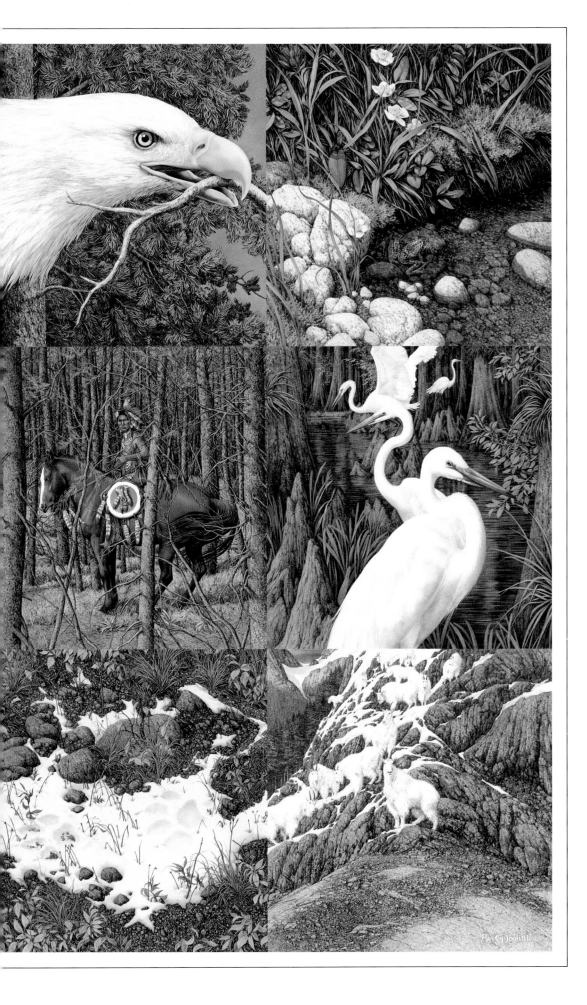

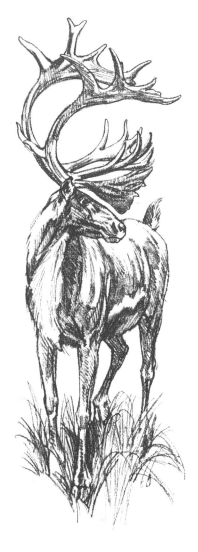

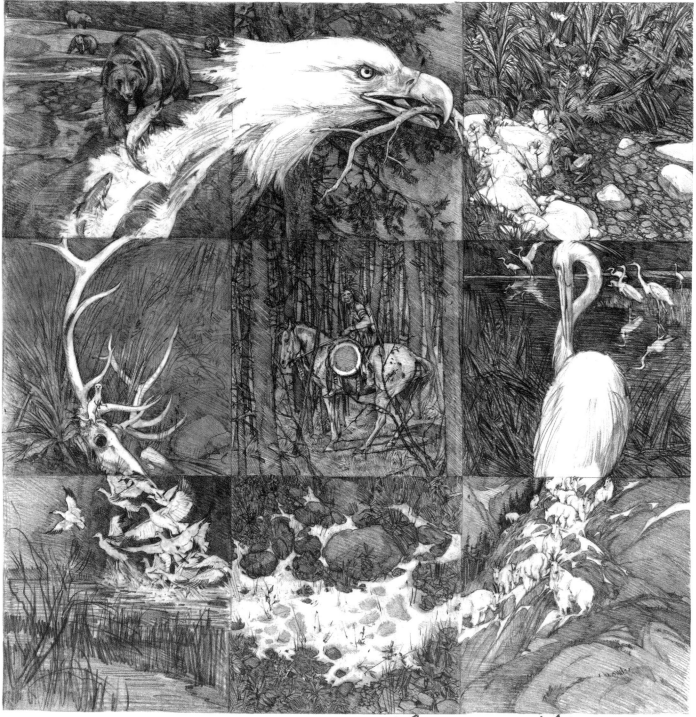

and ready to be projected on a screen, if necessary, for close inspection of a fern or pine cone. Jay does much of this work but Bev says that his input is even more valuable when it comes to capturing an elusive idea. "We talk a lot about my paintings before I begin them. We always have—starting with *Pintos*, which became my first limited edition fine art print. I had a hard time deciding on a background. Jay made a suggestion and suddenly it all came together."

To those who know them well, the Doolittles' teamwork is notable. African wildlife artist Simon Combes, who led them on their first African safari, was struck by it. He says, "We were driving along

in the Land Rover, and suddenly both of them cried 'Stop!'." Bev had spotted a gazelle but Jay was fascinated by the way a shaft of sunlight was splintered by the branches of a thorn tree. "Jay has an artist's eye," Combes says. Together their eyes see twice as much. And, sooner or later, this all shows up in a painting.

There is always something on Bev's drawing board, a work in progress. Today is no exception, and the minute she comes in the door, before she changes from traveling clothes to jeans, she goes over to the board, looks at the drawing, steps back, looks at it from a different angle, picks up a pencil, adds a few lines, considers them, smiles. "That's better," she says, and then draws some more, extending a tree branch, changing a shoreline. Half an hour later she is still drawing. Jayson comes up behind her. "Want to go up to the new house and watch the sun set?" he asks.

Art allows Bev to work at home, close to and with the participation of her husband and son. She misses nothing important on account of it. She's able to spend time where she wants to be, out of doors, in the world's most remote wilderness areas. Best of all, she is able to paint what she wants to paint. "When I'm deciding what my next subject will be," she confesses, "I feel like I'm giving myself a present."

*The Sentinel*, the painting on her drawing board, is an especially generous gift.

## KEEPING THE CIRCLE

*There is still time.*
*There are still forests of aspen and pine,*
*Mountain places where the trails peter out*
*And the winds begin,*
*Trackless tundra,*
*Dark-gliding swamps,*
*Grasslands that have never been mown,*
*And the earth has mysterious ways of*
*    reclaiming its own,*
*Sends violets to push a pavement apart*
*And a sliver of birdsong to pierce the heart.*
                              —ELISE MACLAY

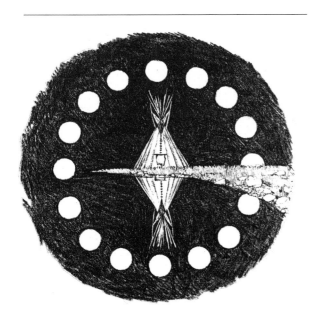

It is a virtual compendium of Doolittle's favorite subjects—nature, Native American Indians, horses, sacred symbols and hidden images. It is also luminously colorful. "I was hungry for color," Bev says. She had just finished *Hide and Seek*, a complex, multi-image puzzle-painting done in the exact same russet and white color scheme she had used ten years ago to create *Pintos*, the painting that launched her print career. "Limiting the palette," she explains, "was part of the challenge. It was fun while I was doing it but when I finished the project, I wanted to dip my brush into every color of the rainbow."

What could be more colorful than a rainbow itself? She talked about it with Jay and Jayson. They recalled rainbows they had seen. The most beautiful had been a double rainbow at Lodge Grass, a Crow Indian reservation. It seemed to be either blessing or guarding the place.

"That's the mood I want," Bev said, and began to visualize it. A lone Indian astride his horse standing guard over his people, over their camp, and over their sacred ways as well. Mountains, sheltering, shielding, lift the spirit to loftier ideals. And hidden, but all-seeing, the spirit symbol of the wolf, nature's own sentinel, watching over all. "I was still thinking in terms of a double rainbow, and I was having trouble tying all these elements together," Bev says. "We were in the car, Jay and I in front, Jayson in back. I figured Jayson had tuned out our talk of painting but he suddenly said, 'Why don't you reflect the rainbow?'"

Bev says that she knew at once that the idea would work. "We all did," she adds matter-of-factly, as if all families instinctively think visually and are as interested as the artist is in solving artistic problems.

Often asked where she gets her ideas, Bev tries to explain that everything she sees and hears and does is stored away in visual form in a sort of mental filing system, ready to be pulled out and perused when she needs an image to express a feeling or thought. Musing further, she says that more often than not the painting she is working on is a source of many ideas for future paintings.

*The Sentinel* is a case in point. When a rainbow is reflected, it forms a circle. "Working day after day on that beautiful reflected arc started me thinking about the circle—no beginning and no end—like the circling sun, the seasons, the life cycle of natural things, the evolution of the planet." Because she sketches first and works out every detail of composition, perspective and color value, painting for Bev Doolittle is a peaceful, reflective process. As she painted *The Sentinel*, she thought about how often the circle appeared in Indian art, artifacts, tools, habitations and ceremonies. She remembered stone medicine wheels

*The artist at work (above). Jayson Doolittle and friend (right).*

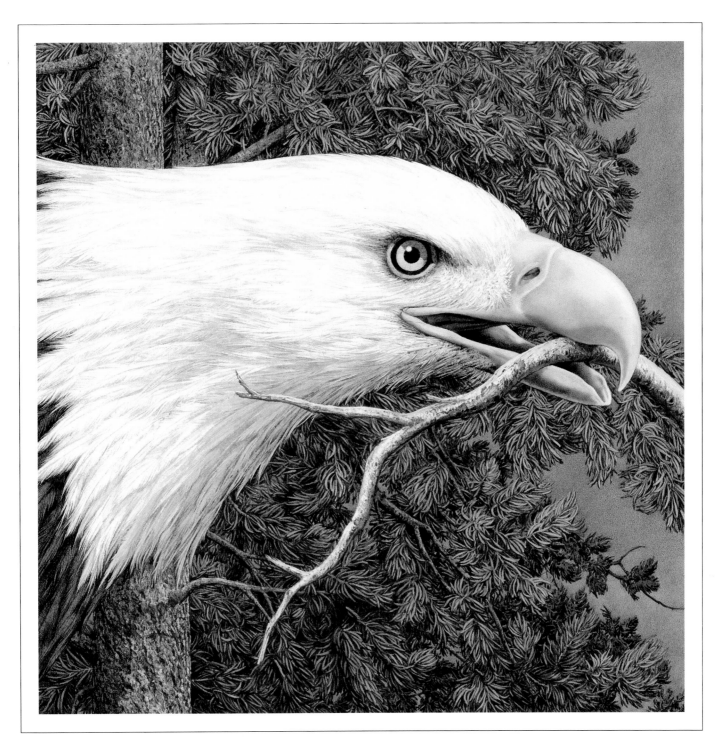

# THE GREAT EAGLE

she had seen or read about, the slabs of Stonehenge, prehistoric sun circle rock carvings in Chaco Canyon. From the beginning of time, she realized, circles have been associated with the mysteries of life. Bit by bit, the realization took shape in the form of a painting. This would have to be more than one painting because it was to depict the chain of life,

the connection between the smallest animal and the largest ones, the fiercest and the gentlest. It would be a circle in which all the links, including man, were equally important.

The painting Bev Doolittle envisioned was to become *The Sacred Circle*, the visual summation of her environmental convictions.

# 2

# The Art of Seeing

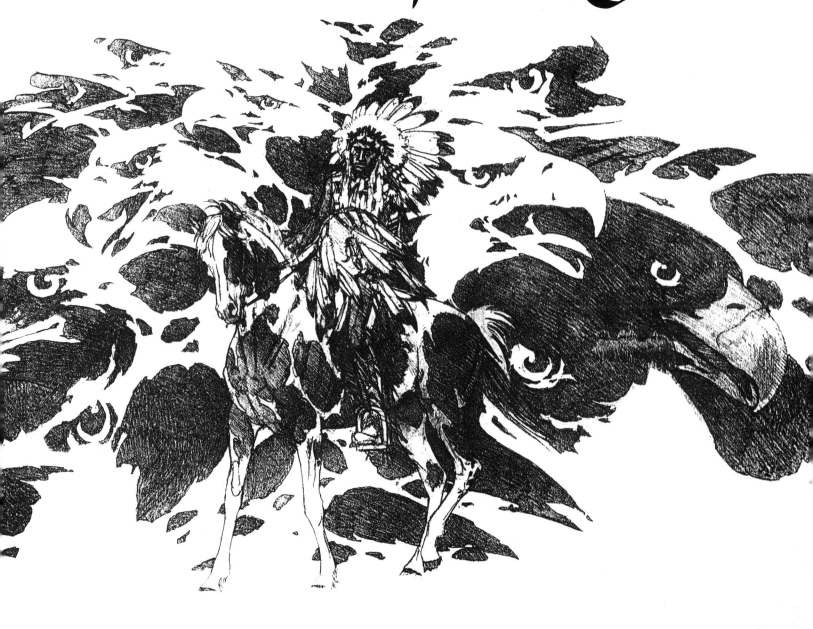

# 2

## The Art of Seeing

"*I* wanted this painting to do more than preach conservation. I wanted it to suggest a different way of looking at the earth, a different way of relating to it." Bev Doolittle is speaking about *The Sacred Circle*, but what she says applies to virtually all her work.

"It's hard for me to put into words the things I feel when I'm out in the wilderness. I want to share it, but I have to do it in a visual way through my paintings."

Visually, *The Sacred Circle* was a daunting project. As the artist conceived it, nine separate wildlife images—each one a complete painting in miniature—must be created in such a way that, when fitted together, they would convey the circle-of-life message. To begin with, the big three—eagle, wolf, bear—would have to be represented, but so would gentler creatures like snow geese and egrets. Shy creatures that frequent remote places—caribou, mountain goats—must be in the picture to remind us of the powerful grace with which wild animals deal with distance, height and space. And small animals must not be overlooked, even those as tiny and unglamorous as the mountain yellow-legged frog Bev once almost stepped on in the Sierra Nevada, at an altitude of over 10,000 feet.

The spirit of each wild creature must be present, too, and the essential nature of individual animals revealed. So the bear is shown being a bear, fiercely foraging, high on the food chain but as inseparable from it as an ant or a cactus wren. The frog is almost invisible, camouflaged and protected by its ability to blend in with its environment. Bleached white antlers in a field of fireweed evoke an annual epic, the whole alpine tundra, streaming and thundering with migrating caribou.

### CELEBRATE THE SMALL

*Take pleasure*
*In the wing*
*Of the dragonfly.*
*Count as treasure*
*The toad's jeweled eye.*
*Celebrate the small,*
*It is all in all.*
                —ELISE MACLAY

The wolf is present in spirit only, but he has left his mark. He will be back.

Some of the images Bev planned to include in *The Sacred Circle* were closely identified with her. The big three were virtually her big three, she had painted them so often. A bear figured in a self-published print from 1978. Designed for a child's room, it shows an Indian child alone with a bow and arrow, confronting a gnarled tree trunk that looms over him like a huge grizzly bear. The power of imagination plays heavily in much of Bev Doolittle's work, and unseen presences haunt many of her

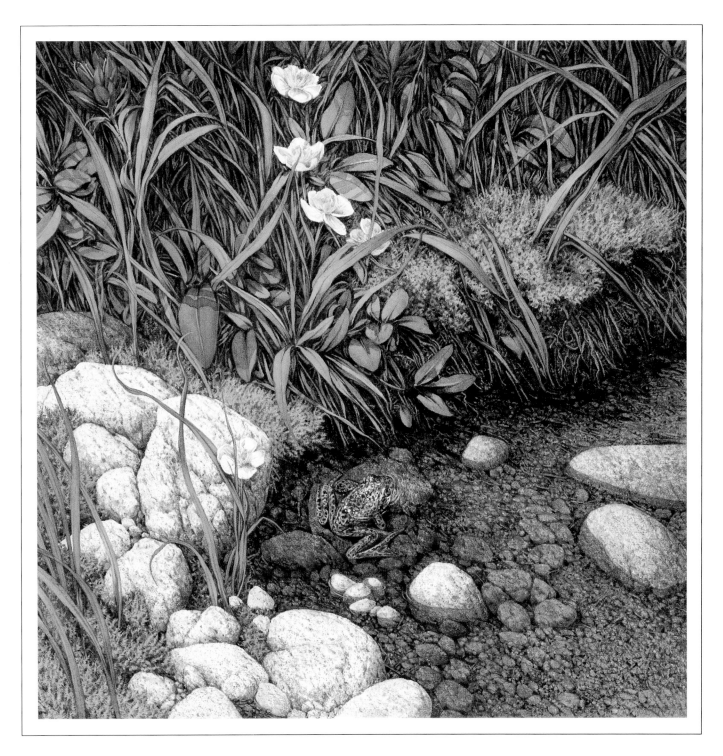

# SMALL WORLD

paintings—and their viewers. Another bear painting, *Spirit of the Grizzly*, which appeared in 1981, elicited a stream of letters, many from children eager to report that there was a bear in the water, too! *Two Bears of the Blackfeet* was one of her most successful "spirit" paintings. And *Doubled Back*, painted in 1988, attracted the attention of "The Bear"

himself, General H. Norman Schwarzkopf, who wrote to say that "hanging at the focal point of the Schwarzkopf living room is your beautiful print *Doubled Back*. My wife presented it to me as a birthday present more than three years ago and it has been displayed in an honored spot in our homes ever since."

For many Native American Indian tribes, the eagle is sacred, the embodiment of power and freedom, the Great Spirit's messenger. Bev Doolittle's view of this magnificent bird is similar. "I have seen eagles in flight in the Lower 48, Canada, and Alaska, and every time it is always, always a thrill. The flight pattern is so beautiful. The soaring eagle is to many the very embodiment of freedom." It was also important to include, she felt, because it is a conservation success story. Endangered in many parts of the country, it is making a comeback. So in *The Sacred Circle* the eagle is painted holding a small branch with which it will build a nest.

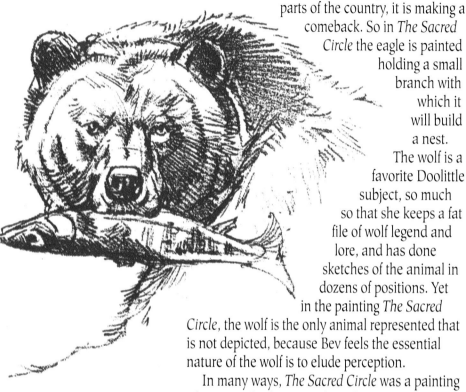

The wolf is a favorite Doolittle subject, so much so that she keeps a fat file of wolf legend and lore, and has done sketches of the animal in dozens of positions. Yet in the painting *The Sacred Circle*, the wolf is the only animal represented that is not depicted, because Bev feels the essential nature of the wolf is to elude perception.

In many ways, *The Sacred Circle* was a painting whose time had come. When she painted it, Bev Doolittle had fully developed her creative powers and had an impressive collection of personal experiences visualized in her memory bank. She had but to pick and choose. She had seen and sketched mountain goats on Parker Ridge in Banff National Park. One September on the northern border of Gates of the Arctic National Park and Preserve between Lake Kipmik and Lake Amitchiak

# FISHER OF THE SEA WIND

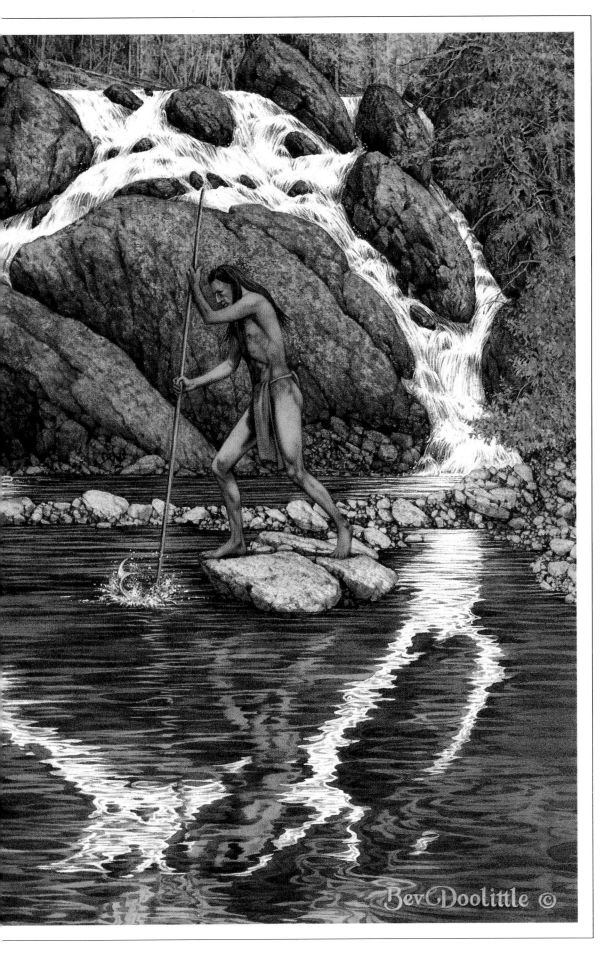

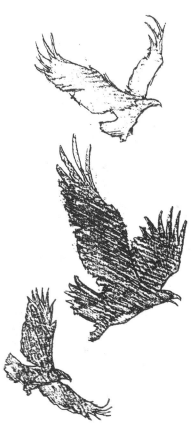

## SNOW GOOSE

in Alaska, she sat in the door of a tent to watch five hundred caribou thunder across the tundra in their annual migration.

Although she had never seen snow geese, she had seen thousands of Canada geese take off from forest ponds. She knew the rush of wings beating, feet churning, droplets of water falling away from the birds in a sparkling shower. "All I had to do," she says, "was wave my brush and turn them into snow geese."

The egret was in the artist's "some day" category, a bird she had always wanted to paint. Studying it, she had fallen in love with its habitat, the dark, moody, mysterious cypress swamp. When it came to incorporating the bird in the painting, the egret proved unexpectedly helpful. Its long neck quite naturally assumed all manner of interesting positions. It proved to be an elegant connection in the *Sacred Circle* design.

From the beginning she knew that in the center of the painting she would place a human being. "Only man can be the keeper of *The Sacred Circle*," she says, "because of all the animals, only man has the kind of intelligence that can protect and preserve the whole." Putting together the last piece of the circle proved tougher than Bev had originally imagined. "I was trying to make the Indian important, to make him stand out. Then I realized that I didn't want to paint him that way. I remembered Chief Seattle's words—'The earth does not belong to man; man belongs to the earth.' I knew I had to paint the Indian the way he lived,

# RETURN OF THE SNOWS

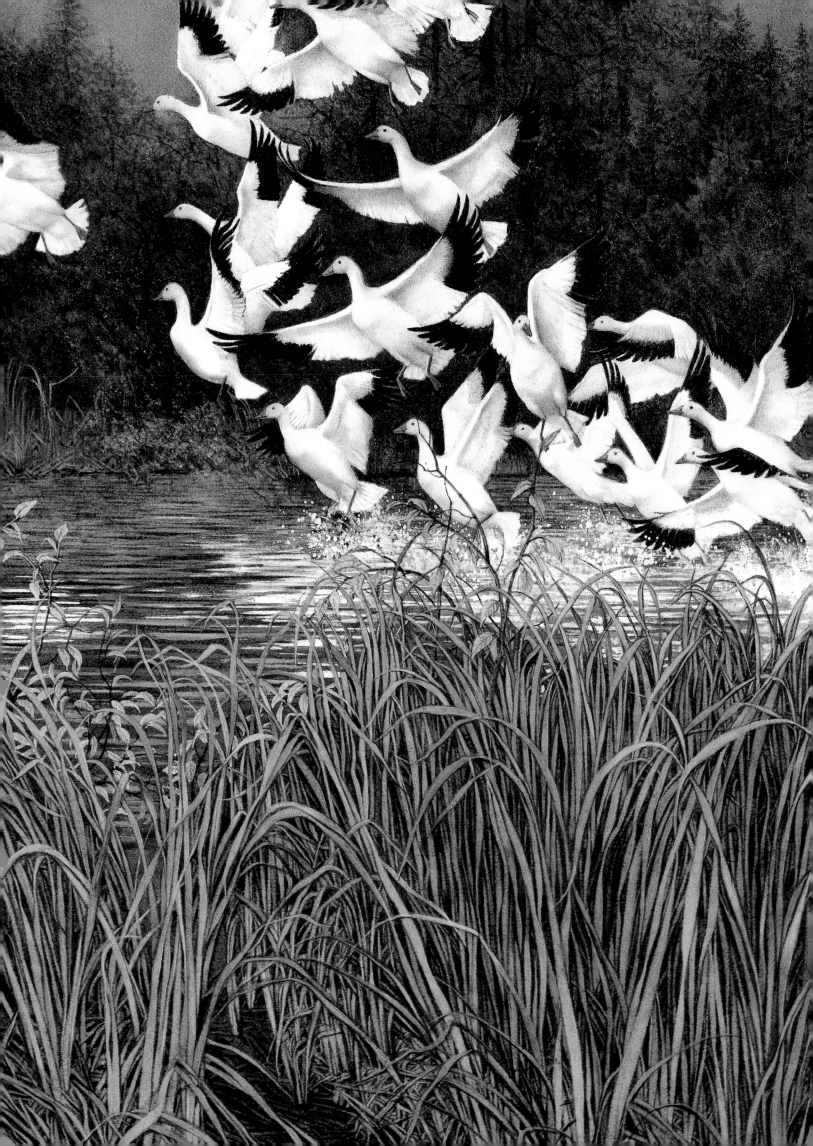

not dominating the earth, not lost in it, just peacefully and happily part of it." In the final painting, the Indian is threading his way through the forest, pausing to gaze straight at the viewer. He seems calm and strong, confident that we will do our part as guardians of the planet.

About the time Bev completed *The Sacred Circle*, the editors at *National Geographic* were putting together a special issue that was to be based on North America before the arrival of the Europeans. They felt that the painting would be an ideal piece to include in the issue. The only problem was that Bev had painted an Indian riding a horse. They asked if she could put together a piece for *The Sacred Circle* that depicted a North

## SONG OF THE TUNDRA

*Arctic dark and hunger coming,*
*Run, run, make the earth move*
*    with your running,*
*Storm the mountain,*
*Leap into nothingness over the ridge*
*And clatter down,*
*An avalanche of breathing boulders,*
*Legs and antlers.*
*Stop your ears with the thunder of the herd,*
*Hear only the fear that drives your hooves*
*Up and down, churning the lake,*
*See only the animal ahead of you*
*And ahead of him another and another.*
*There is no other time, no other place,*
*Survival is pounding blood*
*And gulps of icy air and running,*
*Running, running.*
—ELISE MACLAY

American Indian living the way he might have before the arrival of Columbus.

The right idea was not hard to come by. She was fascinated with the Indians of the Pacific Northwest, the Yurok, Hupa and Karok. Inspired by their beautiful country, they lived simply and peacefully, their lives revolving around the salmon run. To them, the untamed wilderness was bountiful and friendly. She imagined these early people fishing the great Klamath River and its branches, the Trinity and the Salmon. She saw the foamy

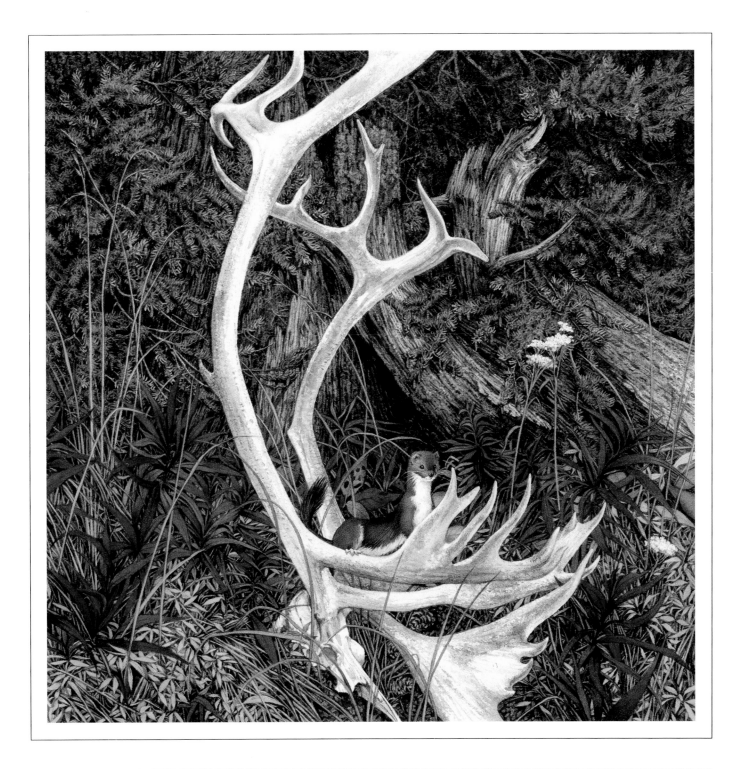

# CARIBOU COUNTRY

rapids, the towering redwoods, the ferny grottos.

She called the finished painting *Fisher of the Sea Wind*. However, much to Bev's chagrin, she was not able to meet the *National Geographic's* tight deadline and neither *Fisher* nor *The Sacred Circle* made it into the issue.

A prodigious amount of work went into *The Sacred*

*Circle*, but it was something the artist felt she had to do. It is Bev Doolittle's personal, definitive and most important statement on the life of nature and the nature of life. Like many of her paintings, it is a story painting, but its narrative scope is as wide as the sky and as intricate as a dragonfly wing. It celebrates reciprocal connections, the greater

## FISHING SONG

*We are the people of the sea wind.*
*We live upriver where streams divide*
*And rapids hide,*
*And blood forgets the pull of the tide,*
*But our sister, the sea wind,*
*Follows and finds us*
*And cloaks us with care,*
*Ties fast our stars with the thongs of her hair*
*Bids us build boats and wait for the day*
*When the rivers foam and we shoot away*
*Like lightning arrows from a thunder bow*
*Seeking the salmon where we know they will go,*
*For every year when the time has come,*
*Our sister, the sea wind, tells them to run:*
*"Go bravely, press on with tails and fins*
*Till you come to the place where your circle begins."*
                            —ELISE MACLAY

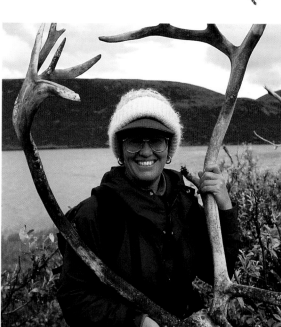

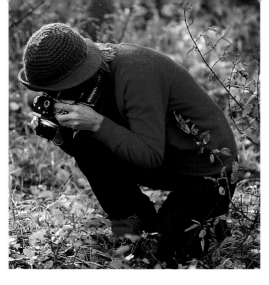

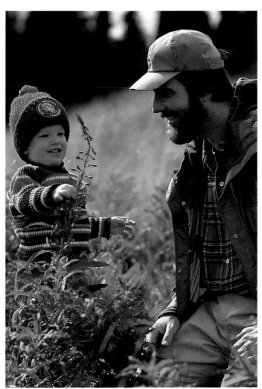

*The Doolittle family: Bev (top and lower left); Jayson and Jay (center).*

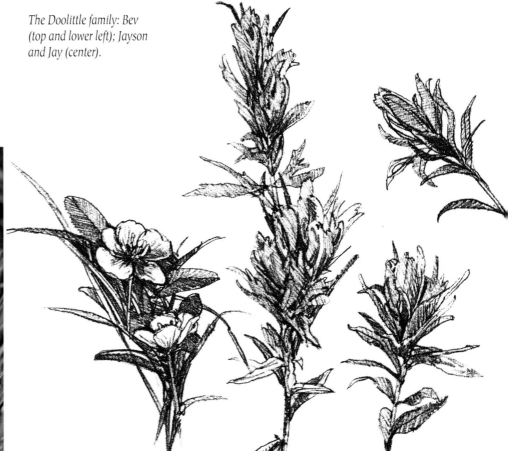

# WHITE MAGIC

continuity and the eternal mystery of the universe.

"There!" she must have said as she put the last brushstroke on the most ambitious project of her painting career. That was that. *The Sacred Circle* was done. Time to get on to other things. A camping trip with Jay and Jayson. Gardening. Visiting their favorite art galleries. Going to craft shows. Going to the movies. But away from art? Never. Not even away from painting. In fact, she was itching to get back to painting outdoors—quick, shimmery watercolor landscapes, designed not for prints but to hold the moment, like snapshots. *The Sacred Circle* was released as a limited edition print with a portion of the proceeds

## EGRET

*"Lady of the Waters" Audubon called the lovely bird*
  *he trained his gunsight on.*
*Watch its motions, he wrote, as it leisurely walks*
  *in the full beauty of its Spring plumage.*
*Not wanton, he was a scientist first, an artist second.*
*He counted, weighed and measured.*
*It is because of him that we know that in all the herons,*
  *when the neck is curved, the oesophagus and trachea*
  *pass above the line of the vertebrae*
  *at its lower part on the right side.*

  —ELISE MACLAY

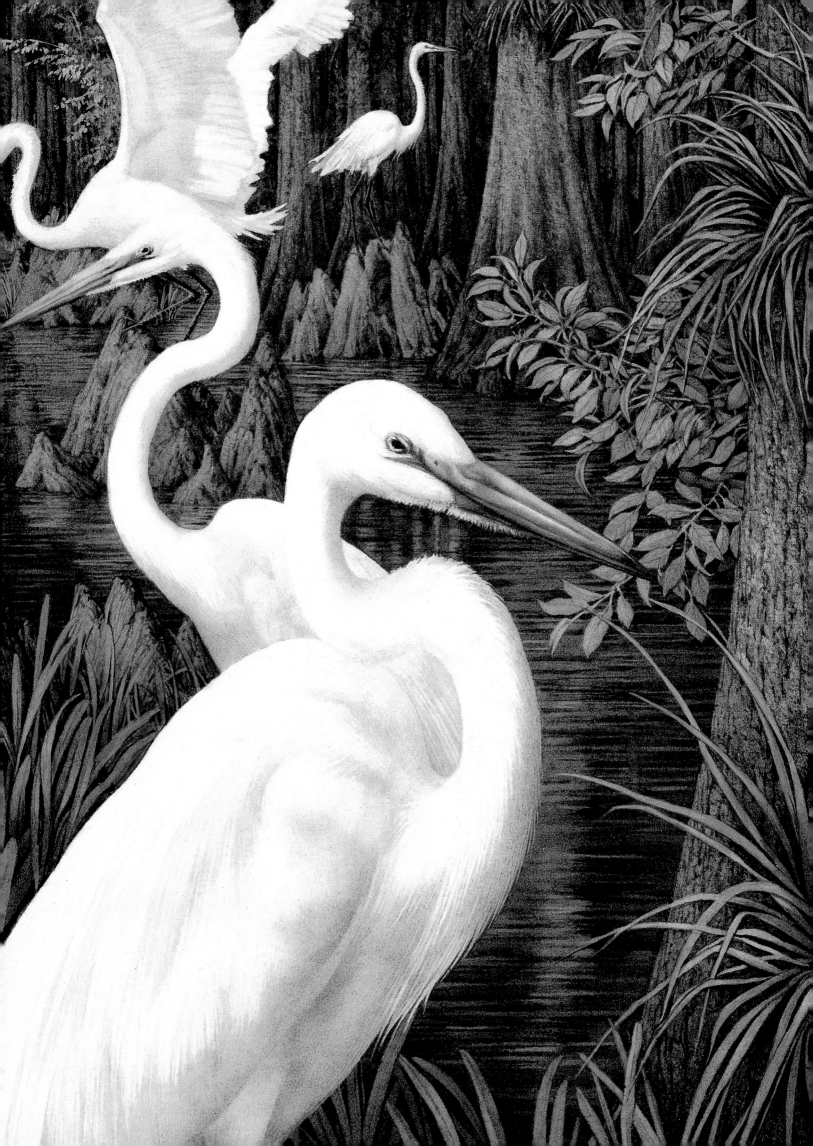

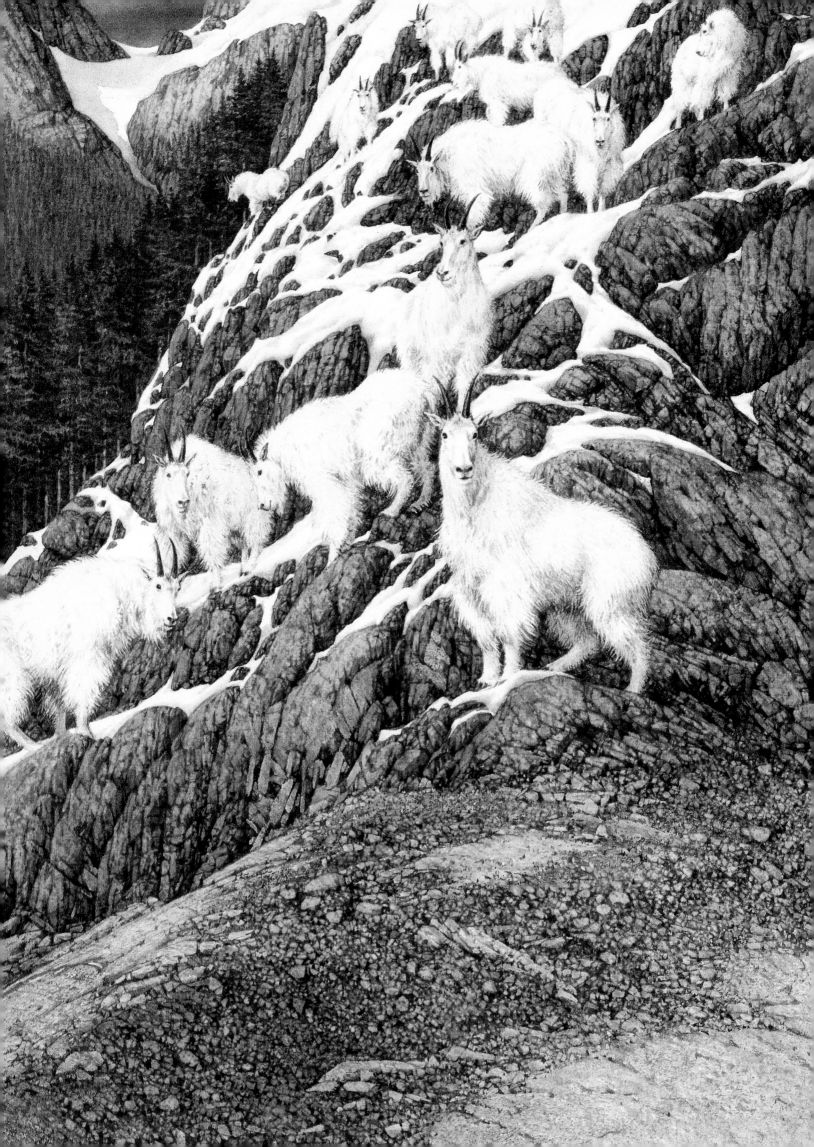

# HIGH LIFE

## KING OF THE MOUNTAIN

*In this thin air*
*Where the landscape is a collage*
*Of white on white,*
*My eyes play tricks on me.*
*I see or seem to see*
*Ice sculptures, two or three,*
*Or is it mist? Myth? Optical illusion?*
*No, it is you, improbably constructed,*
*The color of snow, wading through clouds,*
*Horns piercing the topmost arch of sky.*
*I am here to learn your secret.*
*It is not idle curiosity. I need to know*
*How to fit into my world as you fit into yours.*
*In your world, rifle volleys of stones*
        *spit around your hooves,*
*Boulders plunge into canyons*
*And thunder off walls.*
*Although your hearing is good,*
*You stand your ground.*
*When you move you move slowly.*
*I watch you take a cliff, finding footholds*
*Where there are none.*
*I watch you walk a narrowing knife-edge ridge*
*To sudden nothingness.*
*I watch you stop, survey the abyss and*
        *your alternatives*
*With icy calm. You stand so long*
*My attention wanders and I lose you*
*In the mist and the wind.*
*I find you then, rising up on your hind legs*
*On that tightrope ledge. No room for four feet,*
*You turn on two and stroll*
*With unhurried nonchalance to safety.*
*I begin to see:*
*In your world and mine,*
*Panic is the enemy,*
*There is nothing to be done about*
        *avalanches,*
*The line between life and death is thin.*
*If help is to come it will come from within.*
                                    —ELISE MACLAY

donated to the two largest nonprofit organizations devoted to conservation education, the National Wildlife Federation and the Canadian Wildlife Federation. So there would be thousands and thousands of prints to sign and probably some public appearances, but Bev's intimate day-to-day involvement with the painting was done. "When I

finish a painting," she had often said, "I feel like a mother sending her child off to school. I can't go along. I can only hope I've done those things that make the painting strong enough to have a good life. I'm happy if it wins a prize or gets a good review but I'm no longer really involved. My part is done."

But at this point, history took a different tack. *The Sacred Circle* went out into the world and took Bev Doolittle on a journey of discovery in the form of an hour-long documentary film based on the *Sacred Circle* theme. Leading scientists and educators were enlisted to help guide the project. A Native American spiritual leader was brought in to add his insight. Bev welcomed the opportunity to participate in the production.

"There I was," she says, "learning from the experts and doing things that I'd read about but

## EAGLE

*Where does the eagle go*
*When he flies straight up and disappears into the sun?*
*What does he hear in the clear cold sky*
*With the four winds arching under his wings?*
*What wonders does he see*
*When the gold arrow of his eye*
*Slits the horizon?*
*If I free my spirit to fly with the eagle*
*What will I learn?*
*What will I know?*

—ELISE MACLAY

never dreamed that I'd do—radio-tracking a wolf in the wilds of Minnesota, counting eagles in the southeast and participating in a bear study in one of our greatest national parks."

In working with people who have dedicated their lives to the concept the circle stands for, Bev found herself on the cutting edge of conservation research and education. What impressed her the most, she says, was the way modern technology is able to confirm and amplify this ancient wisdom. "The interconnectedness of the environment," she says, "*The Sacred Circle*'s theme, is the oldest idea as well as the newest. And we continue to find more links."

The link between her paintings and education is actually a long-standing one. Over the years, many teachers had told her that they often took a Doolittle print to school for use in class. Sometimes the images were used to encourage creativity, to get children to use their eyes in new ways,

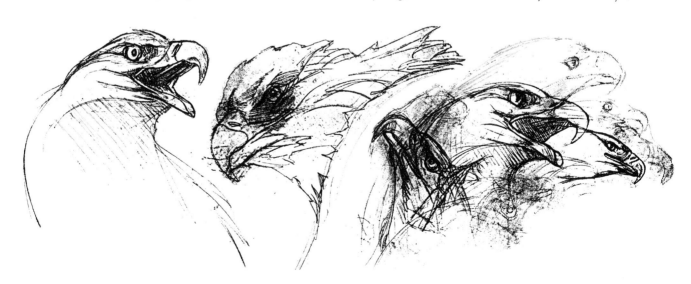

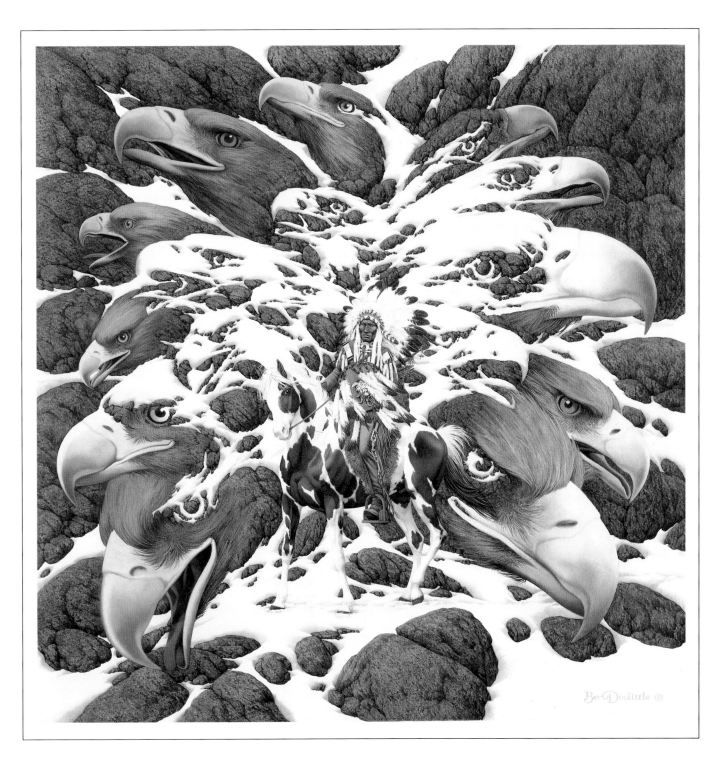

# MANY EAGLES

to really *see*. Some textbooks have used her work to enhance concepts that deal with perception; others, to demonstrate the idea of protective coloring in animals. Occasionally, a whole science unit would be built around one of her wolf, bear or eagle paintings. She has boxes of

letters and essays written by children, copied and sent to her by teachers. For Bev Doolittle there is excitement in these letters; compassion and hope. The earth would surely be safe in these young hands if understanding could be added to their idealism.

# 3

## Art in Action

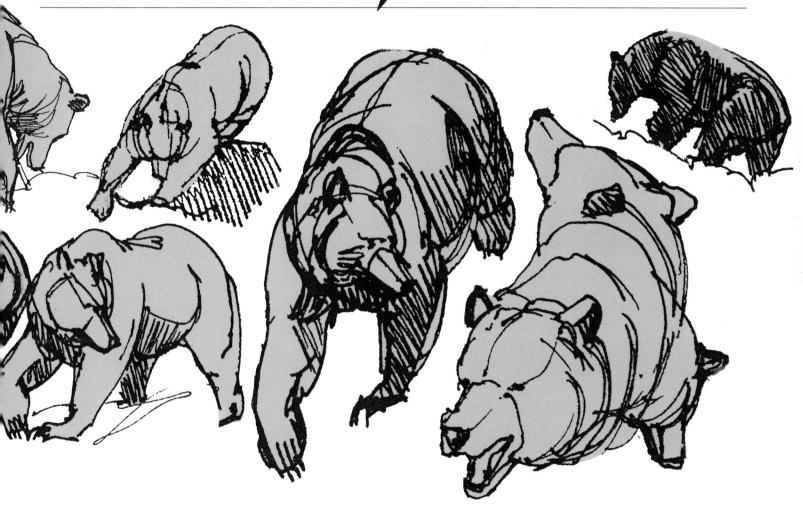

# Art in Action

*BEV DOOLITTLE: It's one thing to research, design and create a painting like "The Sacred Circle" but it's another thing entirely to live it, out here, in places where man and nature must try to coexist. When we set out to film this documentary, I had no idea how much I had yet to learn.*

The documentary Bev mentions in this script excerpt is the hour-long film created to amplify and explore *The Sacred Circle*. Though the film was inspired by one particular image, it reflected the journey that was at the base of all of her work. It was, for her, a journey to the very heart of her artistic inspiration.

"That painting," Bev says, "just wouldn't quit. Usually when I finish a work, it's finished. But with *The Sacred Circle* it was as if the painting came to life. I'd researched these animals, read books, but this was real and happening now. I was touching a live wolf, crawling into a grizzly bear's den, seeing the Sacred Circle ceremony performed in the wilderness by a holy man of the Muscogee Creek."

To make the *Sacred Circle* documentary, Bev traveled to Virginia, Montana, Wyoming and Minnesota where she met and spent time working with wolf experts, eagle experts, bear experts, botanists and biologists, laboratory researchers and hands-on animal behaviorists—men and women in the forefront of modern ecology. "What struck me everywhere I went," Bev says, "was the time, the effort, the dedication of these people—their devotion to the preservation of our beautiful earth."

A segment of the *Sacred Circle* video was filmed in Yellowstone National Park a year and a half after the raging fires that began in 1988 and burned into the fall. Bev says she expected to see black destruction. Instead, she saw lush grass and an explosion of wildflowers. John Varley, chief of research at Yellowstone National Park, spoke in the film of the forest fires from a trained naturalist's perspective: "To an ecologist, there is really no good or bad. It just is. A continuum. When fire sweeps through, the trees themselves replant a new forest. Regeneration occurs virtually instantaneously with the flames."

The circular nature of the ecological equation reflected in the film is one that predates man and is now only beginning to be understood. "I couldn't believe," Varley says, "despite my scientific training in fire ecology, that this place would come back.

## WINTER BEAR

*Snow falls.*
*Owl calls.*
*Bear does not hear.*
*Bear dreams.*
*Dreams himself back*
*To glacial rock,*
*Bedded, embedded*
*In the dark cold fold of winter.*
*It is easy to confuse*
*Buried with dead,*
*Mobile with free.*
*Bear dreams*
*Idyllic journeys along diluvian seams*
*Of agate and chalcedony.*
*Snow falls.*
*Owl calls.*
*Bear fishes underground streams.*
　　　　　　　—ELISE MACLAY

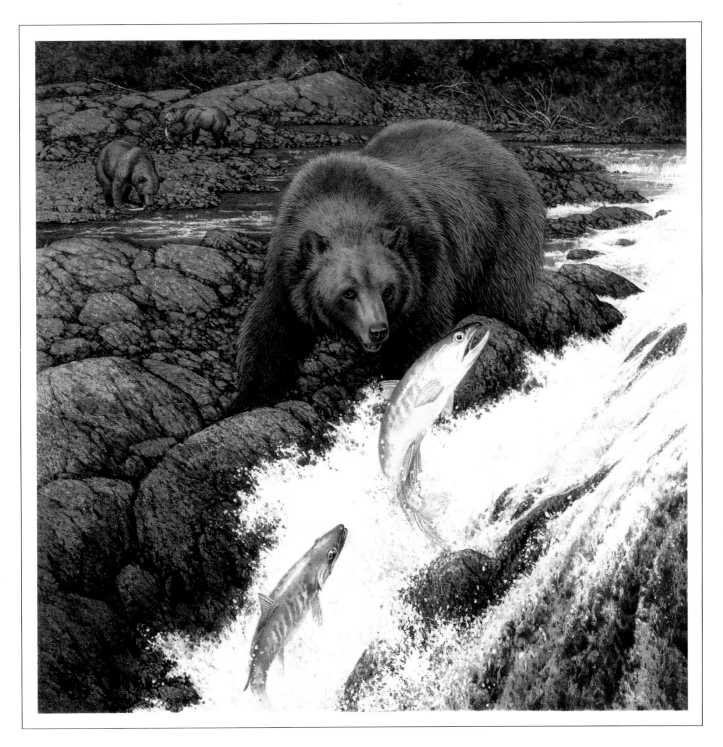

# REAL BEAR

It was totally black. Black as midnight. But two weeks later the grasses started to regenerate. The following spring, this place turned into a profusion of wildflowers that was the most beautiful in anybody's memory."

To naturalists, Yellowstone is exciting because its vast and varied wilderness constitutes the largest intact ecosystem in the United States. To this day it is still inhabited by almost every animal (and with the reintroduction of the gray wolf, every animal) that was here before the first European set foot on North America. Significant connections are not always obvious, but this vast, beautiful park influences and is influenced by what happens in the far reaches of the hemisphere. For example, the park's eagles winter in northern California, the white pelicans in Texas and the yellow-headed blackbirds in Central America.

Varley sees that his mission is to make sure Yellowstone

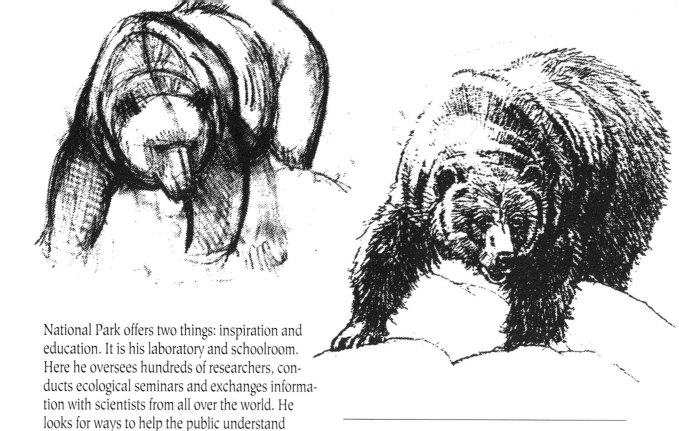

National Park offers two things: inspiration and education. It is his laboratory and schoolroom. Here he oversees hundreds of researchers, conducts ecological seminars and exchanges information with scientists from all over the world. He looks for ways to help the public understand what is being learned and why it is important.

The star of the Yellowstone segment was to be a grizzly bear. The bear is another example of the wildlife that does not recognize the park's

*Experience grizzly country. Breathe deep the solace. Absorb earth and sky. Touch the mountains and hills, rivers and lakes, forests and meadows. Taste the wind. Listen to the message in songs of coyotes, bugling elk and echoes of sandhill cranes. And perhaps, catch a glimpse of the grizzly—the essence of places and things truly wild.*

—STATEMENT OF THE YELLOWSTONE GRIZZLY FOUNDATION

and Marilyn know what they are doing—and what bears do." Steve French was a medical doctor and Marilyn a nurse at the regional hospital in Evanston, Wyoming. They originally became interested in grizzlies while treating people who had had unfortunate encounters with them. Now, with more

boundaries. Tracking would be done by experienced grizzly bear researchers Steve and Marilyn French. A female grizzly and her cubs had been sighted in the area, so there was a good chance of getting a grizzly on film.

Bev had once come upon fresh grizzly bear tracks on the sandy shore of a river in Alaska—where baby Jayson had been playing only hours before. But she had never glimpsed a grizzly in the wild. She says that if she were not a painter, she would like to be a scientist observing animals in their native habitats. "I never dreamed that I would get to go along. The thought of coming face-to-face with a grizzly was awesome but Steve

*Bear and wolf footprint castings (right). Footprint maker (above).*

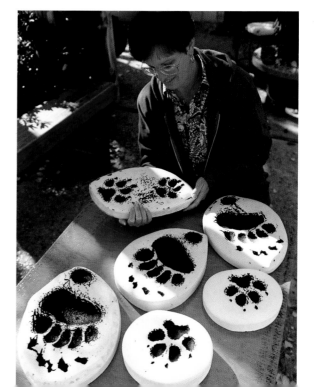

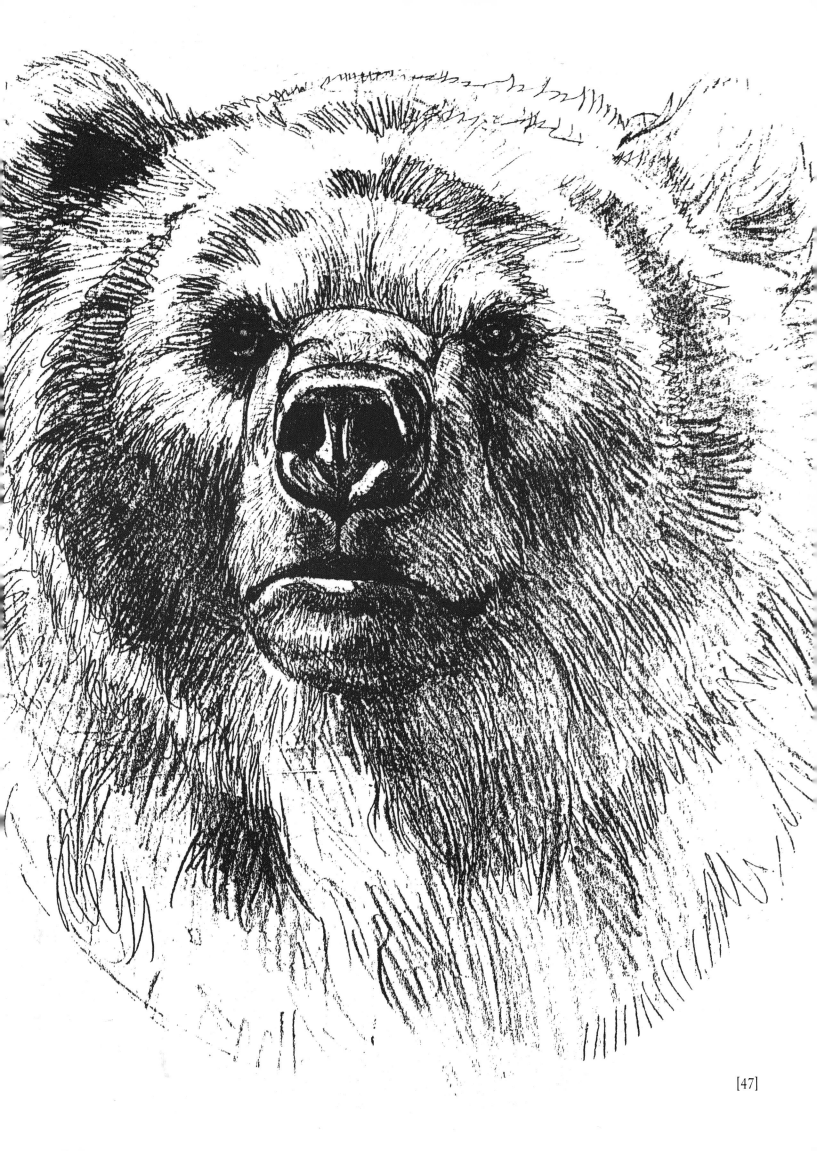

# A SPOT OF SUNSHINE

than 3,000 hours a year of visual contact, including observing 200 predation events, they are nine years into an ambitious 30-year study in the Yellowstone area, the longest natural history evaluation of grizzlies ever attempted.

"We're going to be looking very carefully and quietly as we walk through here," Steve warned the Yellowstone film group. "No sudden movements. Civilization is just over there but any place from here on out, we can bump into bears."

But they did not, although they looked all day. "Seeing grizzly bears requires patience," Marilyn French says.

And luck, Jay Doolittle might have added, because although he was not with the group (he had locked his keys in his car and was walking back to the ranger station), Jay was the only one who saw a grizzly that day—a big female and two cuddly-looking cubs ambling across a meadow. "I got a great view of them," Jay says, "but there I was without a camera!"

The wilderness is not Disney World and wild animals do not behave on cue. But Bev did get to crawl into an underground den only recently vacated by a grizzly in hibernation. She remembers the experience with awe. "I could completely get in there. I could curl up. It was clean and dry. I could see the scratch marks of the claws. I got a feeling

BEV DOOLITTLE © 92

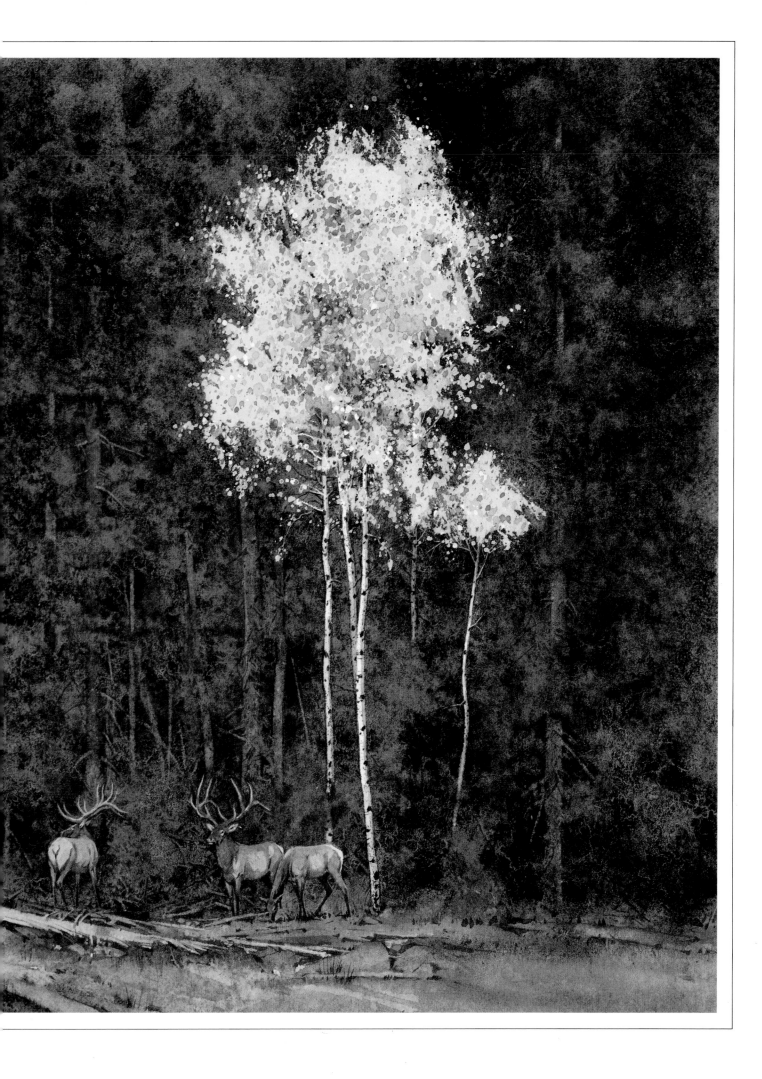

# WOLF TRACK

of closeness, like we were related, like we both belonged to the earth and were meant to share it."

In June of 1993, the Doolittles attended the first Yellowstone Grizzly Foundation seminar in Jackson, Wyoming. The foundation was started by the Frenches as part of their desire to educate the public on this often misunderstood and vanishing wonder. Jay says, "The talks ranged from the emotionally uplifting to the scientific and everything in between. Bev and I had attended similar seminars, but it was the first time that Jayson had been exposed to a group of people completely dedicated to doing what they really believed in." Educating the future generations is something very close to home for the Doolittles.

Bev wanted the *Sacred Circle* limited edition print itself to be dedicated to conservation education. Her son's enthusiasm made her feel good about her decision. The two largest non-profit organizations devoted to conservation education, the National Wildlife Federation headquartered in Washington, D.C., and the Canadian Wildlife Federation headquartered in Ottawa, were selected as recipients of a donation of $10 for each print

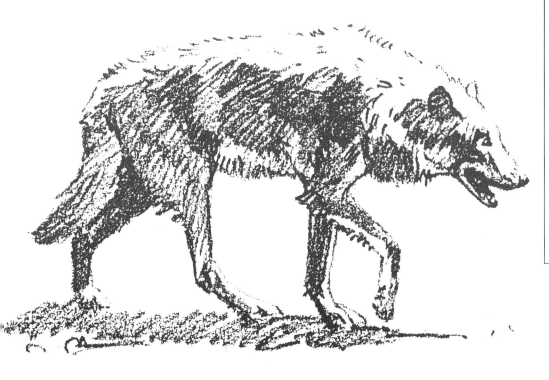

When the fire dies
In the eyes
Of the last wild wolf,
And fierce elation
Throbs no more in his blood,
Will not the moon languish,
Remembering ancient mysteries
Howled in nightly salutation?
— Elise Maclay

Though strong and powerful, wolves
settle most disputes within the pack not
by fighting and bloodshed but through
ritual and fine-tuned communication.
— Wolf Haven International

Run with me, Wolf Brother,
Teach me your cunning and strength,
Teach me to be like a wolf, Wolf Brother,
Run with me.
— Elise Maclay

In Indian sign language the gesture for
scout is the sign for wolf.

sold by the art publisher. The money that was raised was directed toward conservation education. In addition, galleries that sold *Sacred Circle* gave copies of the educational video, free of charge, to schools throughout the country.

"But I probably learned more than anyone else," Bev says. "For example, to film the documentary, we went to Virginia, to the James River, where, in 1973—because a chemical similar to DDT was dumped into the river in large quantities—bald eagles and ospreys in the area had disappeared. Since then, major clean-up efforts have been going on, pollution levels have declined and in one morning I counted nineteen eagles and ospreys within a few hundred yards."

The experience she describes took place when Edward Clark, Jr., Director of the Wildlife Center of Virginia, and Dr. Mitchell Byrd, a leading raptor scientist, took Bev and the film crew by boat to view a major region where up to 150 eagles live and breed throughout the summer. Also in the

area was a rookery built on the skeletal hull of an old barge—one of many that had brought in the chemicals that were part of the destruction of the river; yet when dumping was stopped and the barge was abandoned, nature very quickly took it back to herself.

"There are," Ed Clark told Bev, "great lessons to be learned from the environment. Ecosystems are very fragile and we need to look at things in their entirety but if we make the right decisions and act on them, things can be turned around." On the James River, nature had not only reclaimed a barge in the very shadow of the chemical company that polluted the river, but had also created an important breeding site for birds that are the harbingers of environmental well-being.

Because habitat has always been significant in her animal paintings, Bev Doolittle spends a great deal of time in the wilderness, sketching and photographing the landscape, getting the feel of it, because, she says, wild animals live so close to the

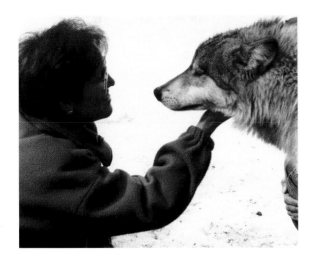

the animal world. So she was thrilled to find herself radio-tracking wolves near Ely, Minnesota, with Dr. L. David Mech, a research biologist for the U.S. Fish and Wildlife Service and a leading authority on North American wolves.

Research expeditions like the one in which Bev participated aim to do more than track the movements of a particular wolf. The objective is to learn more about how the wolf utilizes its habitat and what constitutes the internal anatomy of a home range—information that is needed for wolf recovery projects throughout the United States. Fewer than 100 wolves exist outside Alaska and Minnesota, except those in captivity.

"I've sketched captive wolves," Bev Doolittle says, "but a captive wolf is a different animal. To learn about wolves, you have to observe them *being* wolves—in the wild."

The thought of wolves in the wild figured heavily in the making of *The Sacred Circle Chapbook*.

An elegant record of the artist's impressions in the creation of *The Sacred Circle*, as well as her journey, the design called for an original companion piece of art. Bev saw at once that the project posed two challenges. First was the small size. Second was the need to find a subject that related to but did not duplicate the animal images in the original painting *The Sacred Circle*. She tells the story: "While I was pondering what to do for the

land that they are almost part of it. Her camouflage paintings are a means to express this thought visually and accurately.

In a Doolittle painting, every grass is in season, every footprint is in scale, thanks to meticulous research on the artist's part. For Bev Doolittle, facts are the key to a luminous understanding of

## GRAY GHOST

*I wake in the eye of the morning*
*Before the forest remembers it's alive.*
*Fir and pine are black bars*
*Drawn in charcoal on a parchment sky.*
*The horned moon is a fragment of antler*
*In the frozen lake.*
*Nothing moves, has moved,*
*Or ever will, I think,*
*As stillness seeps to the bone: Alone is alone.*
*But when I walk out*
*I see that a gray wind has circled my camp*
*On silent feet.*

*—Elise Maclay*

## WALK SOFTLY

*Walk softly,*
*Earth receives*
*Foot and paw,*
*Hoof and claw*
*With equal grace.*
*But it is the way of the wild*
*Not to overstep*
*The bounds of hospitality.*
*This is a wild place.*
*Follow me,*
*And leave no trace*
*That rain and snow*
*Cannot erase.*
<div align="right">—ELISE MACLAY</div>

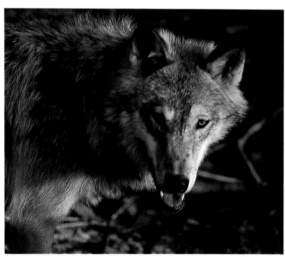

Chapbook print, my eye fell on a plaster cast of a wolf track I had made in Alaska years ago. I took it from my bookshelf and put it on my copy machine and made a paper copy. The full-size track made a powerful graphic image on the six-inch square of paper. I saw at once that it had the strong design and simplicity I needed for the Chapbook print. A footprint is, after all, the first impression of a live animal on soft earth or snow. It also had the quality I look for when I decide what to paint—a suggestion that what you see is only a small part of all that there is to be seen.

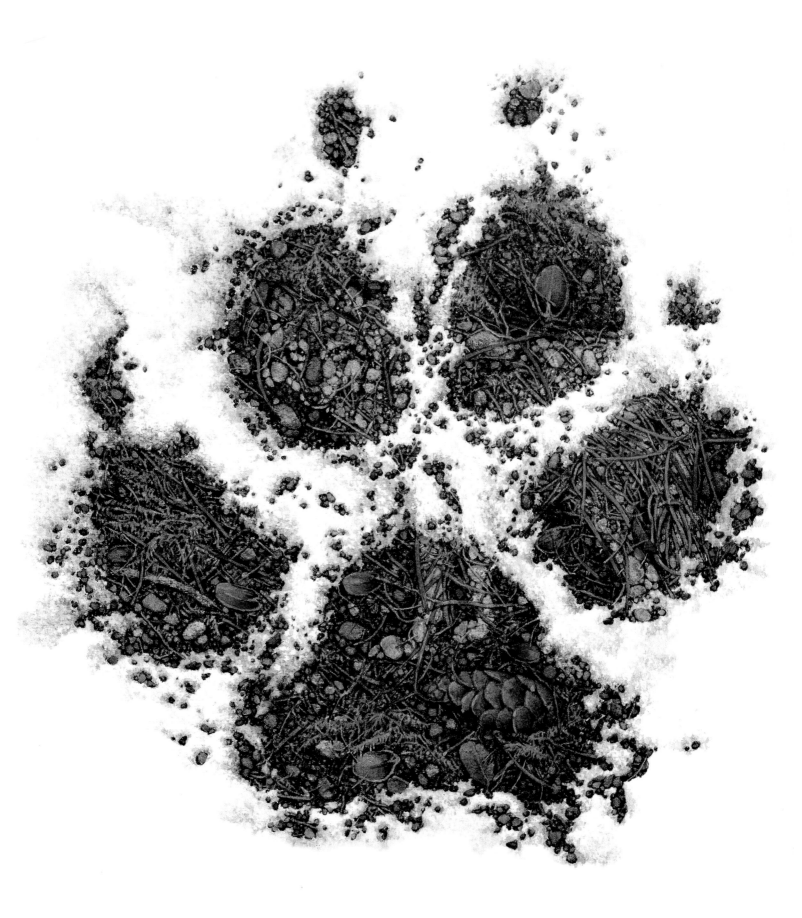

WALK
SOFTLY

# 4
# Sharing a Vision

# 4

# Sharing a Vision

They camped in a high meadow rimmed with granite peaks. The mountain air was clear, scented with spruce. Darkness fell. They lay in the open watching stars and planets turn the sky into a second meadow strewn with flowers of light. Birdsong fell away but the murmur of a brook sounded all night. In the morning she found two arrowheads.

Remembering the incident, Bev Doolittle shows a visitor one arrowhead. "Jay and I found it in the Sierras," she says. "When I picked it up, it was like touching the hand of the Indian who made it. I thought, they were here, they *lived* here. This was their home. They never had to go back to city life the way we did." As long as she can remember, Bev has been thrilled by the idea that before North America turned into a place of high-tech cities, Native Americans lived here, close to the earth, communing with rocks and trees and calling the animals "Brother."

This communion with wild things, this sense of unity with the earth is something she feels she understands because she has experienced it—the cathedral-like silence of a redwood forest; a desert thunderstorm; watching a couple of kit fox cubs nuzzle each other in the gold afternoon sun. She understands but, she says, she can't put it into words. To some extent, no one can. And art, not language, is Bev Doolittle's medium.

What she wants most to express almost always comes to her in picture form along with an inherent eagerness to pick up a paintbrush. When a painting concept begins to materialize she finds that she needs more to go on than the feeling. "You can't just paint 'Indian,'" she explains. "You have to paint Blackfeet, Sioux, Crow. You have to

know how they lived, what they wore, what they carry when they move camp or scout buffalo." So she turned to books and museums, visited Indian reservations, talked to teachers and elders. She came to know a great deal about beadwork and baskets, shields and lances, tools and tepees, and although she found this information fascinating, it was not, for her, an end in itself. As integral as this knowledge was to the creative process, *her* creative process required her to begin with a greater underlying truth.

Love and respect for the earth and all its creatures—that was the message she wanted to convey. In details and accuracy there is a start, but in a Doolittle painting they are never the point. If one looks long and often, there is always more than meets the eye. And Native Americans are among those who are first to see it.

Bev's clarity of focus has enabled her to create art that is free of pedantry and politics. In letters and in person when they meet her at art shows they tell her that they recognize in her paintings a spiritual belief that is like their own—a celebration of unity and wholeness.

A holy man of the Muscogee Creek, Marcellus Bear Heart Williams, as part of a documentary, conducted an authentic Sacred Circle ceremony in which the Doolittles were participants. The purpose of the ceremony was to call on the hearts of people to rekindle a true appreciation of all life-forms. "In order to try to bring this about," Bear Heart explains, "we set up the circle and allowed people to come in and share in our appreciation. We are asking the Great Spirit to bless what we were trying to do, not only for ourselves today but for those that follow after us, for those not even

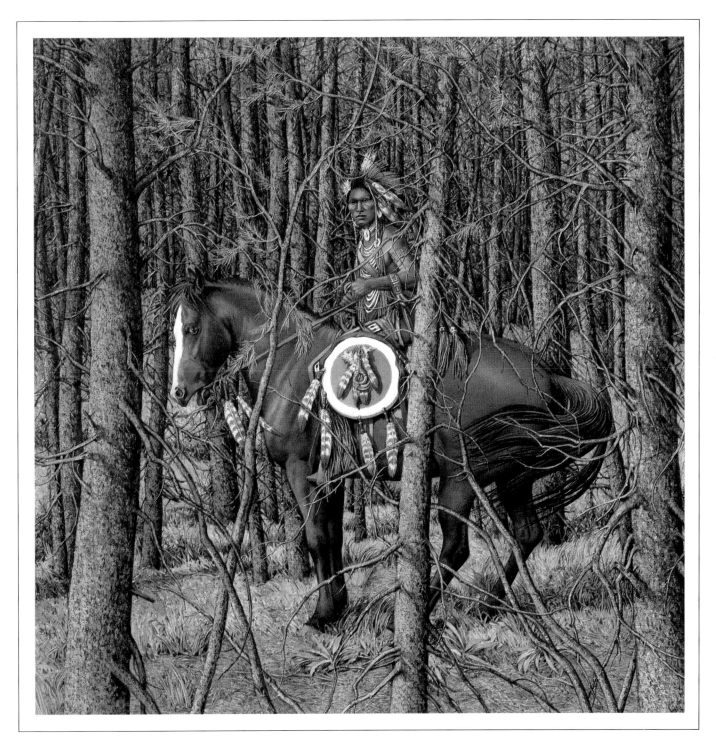

# EARTH BROTHER

born yet, so that there might be a truly better tomorrow."

It was an experience Bev Doolittle says she will never forget. "Bear Heart's spirituality and his genuine love of beauty, animals and freedom really touched me. We had to be invited into the circle, which is representative of our world, the greater circle. We were blessed before entering the sacred hoop, which was formed with sage. This was a small part of a much more complex tribal ceremony, but participating even in this small, public part of the ceremony made me feel privileged and thankful. At that point, I truly understood and believed that there was a deeper purpose in creating the *Sacred Circle* painting."

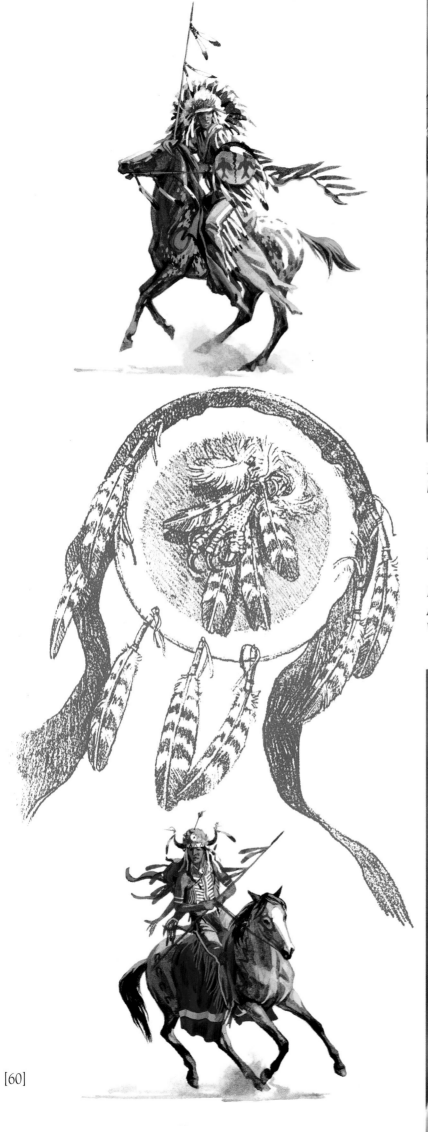

If you look at a painting long enough you can see the heart of the artist that painted it.
—MARCELLUS BEAR HEART WILLIAMS

\* \* \*

If you talk to the animals they will talk with you
    and you will know each other.
If you do not talk to them you will not know them,
And what you do not know you will fear.
What one fears one destroys.
—CHIEF DAN GEORGE

Bear Heart, Muscogee Creek holy man (above left, lower left, and above right). Bev Doolittle and her element (middle, right, and lower right).

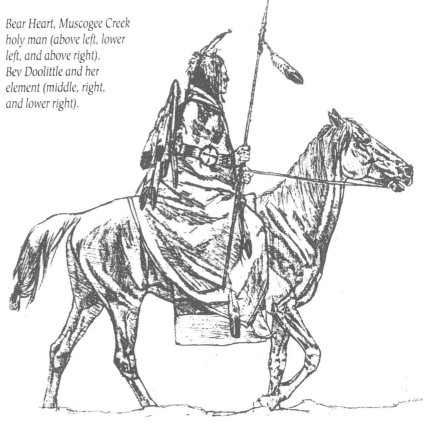

At the end of the day, as they sat chatting around the campfire, Bear Heart, with a sweeping hand gesture, told Bev, "In what you are doing, you are keeping *all* this alive. You may think your canvas is inanimate, but what you put into it speaks for itself. It cries out, 'Look at me! Look at me, full of life, in harmony with the landscape!' In my case, when you paint a grizzly, you're sustaining the life of my father and of my father's relatives, because I am of the bear clan. My father was of the bear clan. I regard all bears as my father."

Jonathan Felt, who produced and directed two films about Bev Doolittle's work, says that the thing that impressed him about her was her unflagging eagerness to learn. Because her paintings were featured, she might have considered herself to be the subject of the film. Instead, she was wrapped

# EAGLE HEART

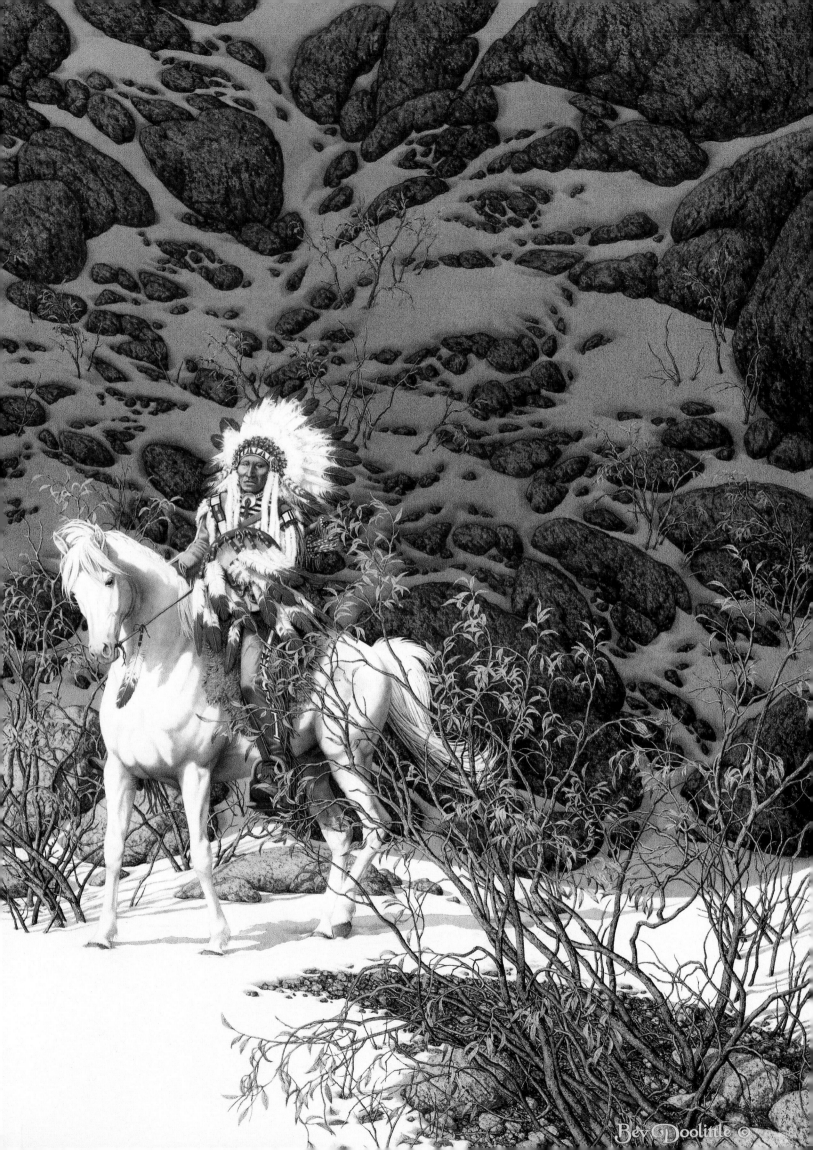

## WHEN THE WIND HAD WINGS

up in getting the larger story across and often, like her camouflage paintings, faded into the background when the experts were talking. As far as she was concerned, they were the stars of the film. She listened carefully to everything they had to say and almost never took a break for fear she might miss something.

Those who have walked in the forest or desert with Bev Doolittle know she is constantly pausing to examine and marvel. The Indian idea that the earth is a book to study and learn from makes perfect sense to her. Speaking on this at an art seminar in 1993, she said: "Each animal has been endowed with special gifts. We are human beings. Our gift is the ability to learn. The Indian learned from animals. They showed him how to live in the wilderness. They became his teachers. The Indian prayed for his animal teachers and was grateful for their gifts. He also understood his place as being no more or no less important than all the other creatures. He was just one part of a complex and wonderful whole. Modern man has lost this insight. We live in crowded

...ild things whose ways were ours when the wind had wings.

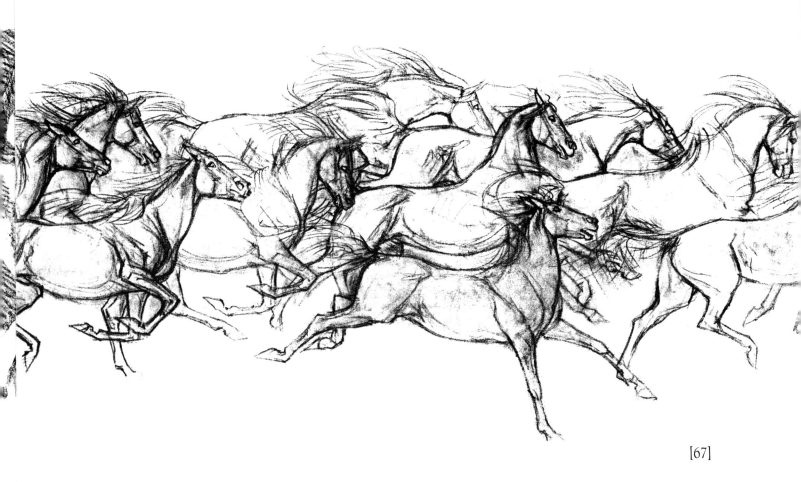

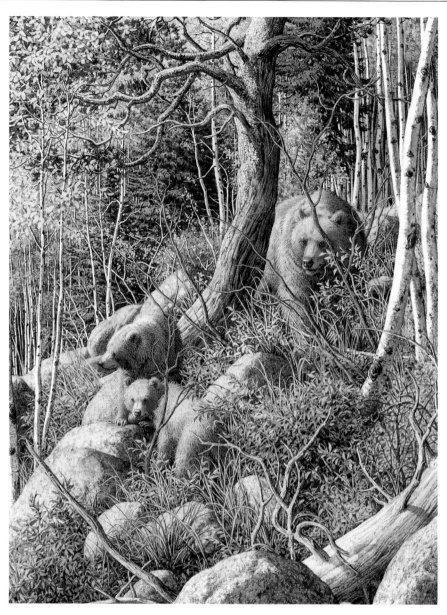

When he got home, he wrote them down and showed them to his wife. His thoughts became the inspiration from which a piece of art was born. She picked up a pencil and began to sketch. The result was a painting that emerges with dreamlike delicacy from the mist of time and sweeps across the horizon into a future unknown. Running directly under the image, *When the Wind Had Wings*, are the thoughts Jay wrote refined into poetry by Elise Maclay, a friend Bev calls "an artist who paints with words—a kindred spirit."

Even as she was signing this print and making public appearances on its behalf, Bev Doolittle was thinking about what she would do next. She wanted something accessible, something that would reach a large audience and make them think. Wild animals were fading away, their habitats gone, their numbers thinning. The thundering clouds of buffalo that once rolled wild and free from horizon to horizon across the Great Plains have been reduced to farm herds, and the buffalo wolf is now extinct. The caribou have dispersed into the taiga and most schoolchildren have never heard the sweet plaintive wail of a loon. What if this perilous drift continues? What will it be like to wake up one day

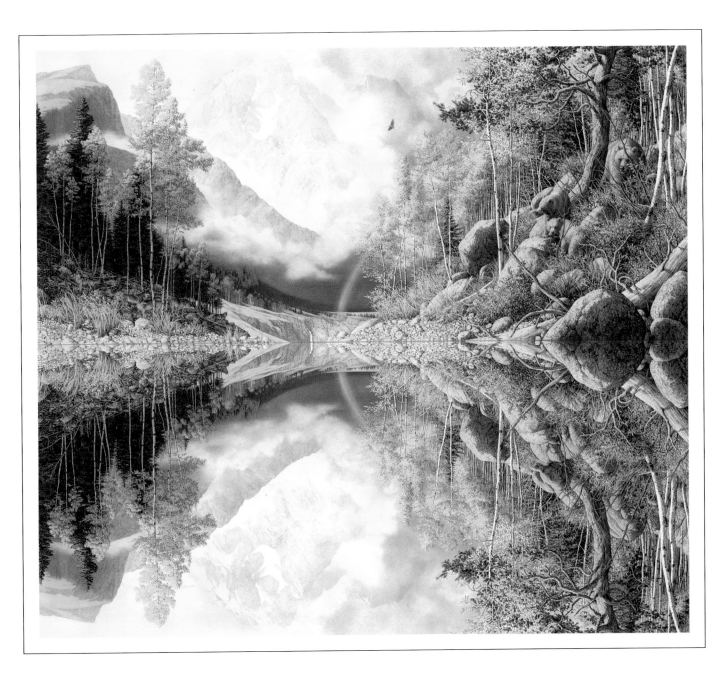

# WILDERNESS! WILDERNESS?

to find you are in a world without any wild animals?

That was the question she wanted people to ask themselves. She decided that the best way to get them to do so would be to show them before and after photos. So she set about creating the artistic equivalent: *Wilderness! Wilderness?* To Doolittle the wilderness is "more than beautiful scenery. It is the dynamic interaction of all the plants, animals, rocks, water and air."

She goes on to say, "Sometimes we rationalize that it's enough if a place is undeveloped and presents us with a postcard-perfect landscape. Since wild animals are seldom seen, it's easy not to notice their absence. But each missing plant or animal, seemingly insignificant in itself, creates a vacuum over time. What we perceived as wild is no longer so. It is something less. We are left with a beautiful landscape that was once so much more."

*What is man without the beasts?*
*If all the beasts were gone,*
*men would die from great loneliness of spirit.*
— CHIEF SEATTLE, SQUAMISH
AND DUWAMISH

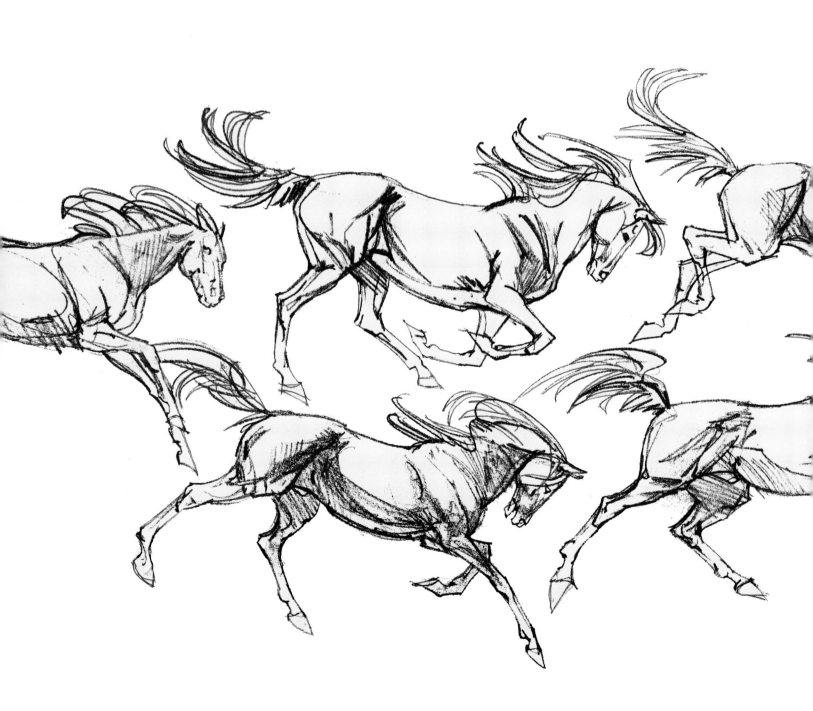

# 5
## New Directions

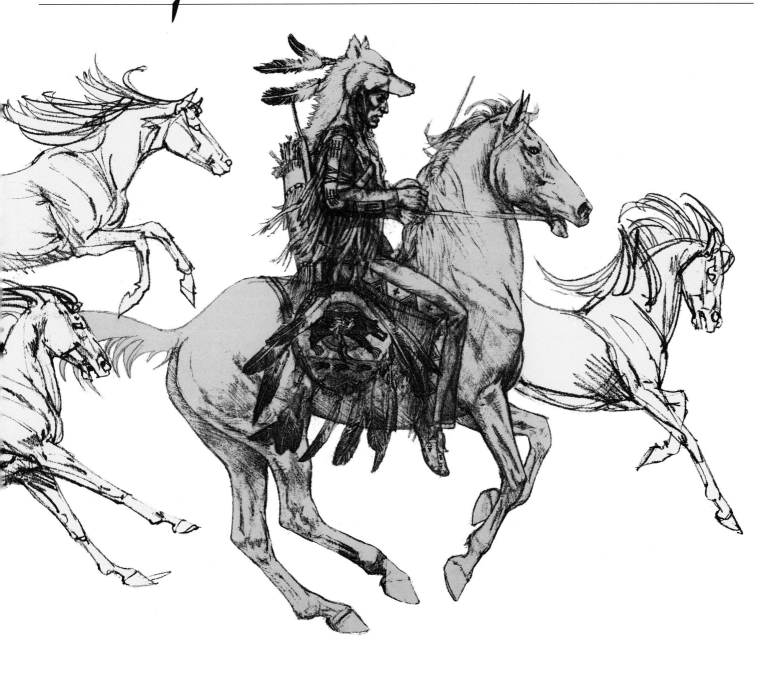

# 5

## New Directions

Asked how long it takes to create a painting, Bev usually answers that it takes six months, more or less. Her "more or less" encompasses considerable divergence. For example, two years elapsed before she could get back to her quick pencil sketch, shape and reshape it and finally paint *When the Wind Had Wings*.

"You can't compromise the idea," Bev Doolittle says. "You have to make it work. No matter how long it takes." *Prayer for the Wild Things*, the most complex, ambitious Doolittle painting to date, is a case in point. Bev began it, in a sense, sixteen years before it was issued in print form. It's a story she likes to tell.

"Sixteen years ago on our way to northern British Columbia, Jay and I stopped off in Rocky Mountain National Park. We were traveling from west to east and were about at the tree line, descending into Estes Park, when we came across this wonderful spot, a rocky outcrop on a mountainside. Bare trees—twisted, gnarled juniper and white bark pines—were clinging to the rocks. The whole place was shrouded in clouds and it was very, very mysterious. We had to stop, get out of the car and take a couple of pictures. We didn't really know why. It just felt like a place that someday I would paint."

Eight years later, Bev was talking to Jay about a painting idea: An Indian on a vision quest, standing alone, in a place of outstanding natural beauty. They knew hundreds of beautiful places, but what Bev wanted to paint was a landscape that inspired awe, that had an aura of the sacred about it. For days, they discussed possible sites. Then Jay remembered the towering cliff in the Rocky Mountains, the powerful impact of its beauty, the way he and Bev had fallen silent in its presence. He got out their Rocky Mountain photos.

"That was it," Bev says. "I knew at once that this strange rock outcropping was the right setting for the painting I had in mind. But I needed more photographs than the two we had taken. I needed detailed things, lichen and flowers, closeups of grass and pine cones and tree bark. However, I was just about to go approve prints and sign them, a process that takes weeks. Jay ended up going with Jayson (who was three at the time).

"They went and although the weather was terrible, Jay got some good pictures but I still couldn't make the idea work. So I just sort of put it on the back burner."

Six years later, while their son attended a National Wildlife Federation camp near Estes Park, Bev and Jay spent twelve days photographing the rocky crag that had been haunting them for so long. Bev says, "We must have used twenty rolls of film on this one particular place. We got pictures of it in different light, in different moods, at different times of day."

During all those times, it looked like a place of prayer, a kind of wilderness altar. Doolittle imagined an Indian going there, not on a vision quest, but to pray for the wild creatures he called brother. Mentally she began to picture them—fox, elk, moose, coyote, mountain lion, boreal owl, magpie, kingfisher, ermine, bear, more and still more, taking their places in the painting in her mind. Silently on hoof and wing and paw, they moved in a spiral up and up, toward the Indian, toward the eagles in the snow-spangled sky. Here was a concept with grandeur to match the mountain.

The painting, which she was already calling

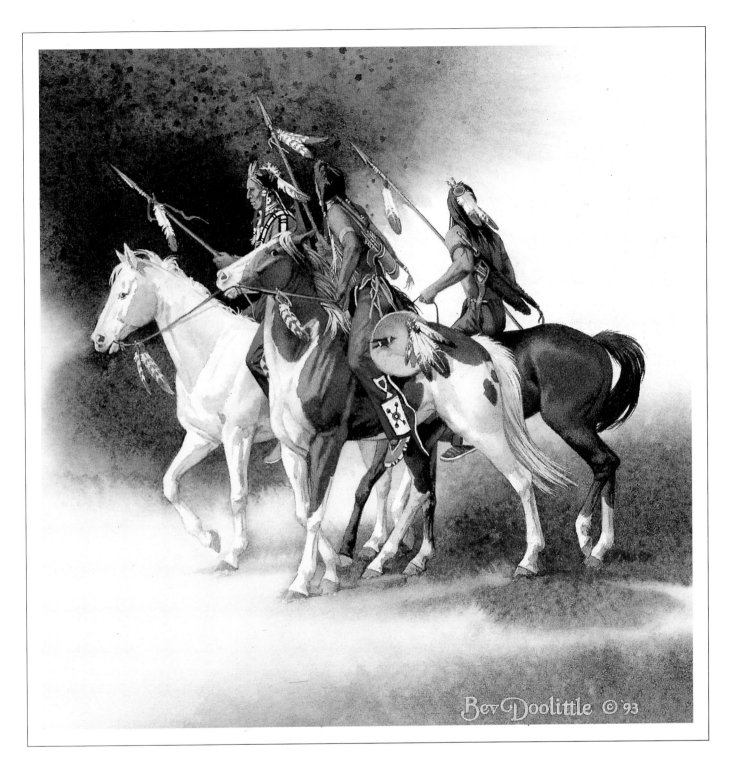

# pLENTY coups

*Prayer for the Wild Things,* was also the most formidable challenge of Bev Doolittle's career. She threw herself into the project, starting with a thumbnail sketch of the concept and a wish list of animals she wanted to include, a list she kept having to expand. "They had to be Rocky Mountain animals," she says, "and I had to include my favorites— the big, impressive animals like the bison, mountain lion and bear. But there were others, like the little weasel or raccoon. They were really important because they're everywhere, an integral part of the Rocky Mountain landscape."

Because the shape of the mountain suggested it and because she was familiar with the American Indian con-

# PRAYER FOR THE WILD THINGS

cept of eagle-as-messenger, Bev knew from the start that there would be spirit-eagles in the sky "to carry the prayer for the wild things to the Creator." But when she began to design the painting, she did not know that before she was through, 26 species represented by 34 animals and birds would move, flow, fly and hide in her landscape.

Bev Doolittle also had no idea that the mist-shrouded rock she had chosen to paint because of its sacred aura was located less than a mile from a genuine Indian prayer site. She learned this only after she had completely finished *Prayer for the Wild Things* and was lunching with Curt Buchholtz, executive director of the Rocky Mountain Nature Association. He described the sacred site to her. It was, he said, very old, close to a saddle in a ridge where Native Americans had regularly driven game over a cliff, beginning perhaps more than 10,000 years ago. He said that Indians still use the prayer site today, leaving behind sacred objects like feathers and beads.

In many ways, the story of *Prayer for the Wild Things* mirrors Bev Doolittle's artistic life: A search for truth and beauty, encompassing enormous challenges, deep satisfactions, prickly difficulties and flashes of unexpected delight. In the latter category was the opportunity to see the painting come to life musically through the talent and imagination of one of her favorite musicians.

In 1968 Paul Winter first heard the songs of humpback whales and was astounded by the beauty of their voices and the intricacy of their melodies. Since then the sounds of animals have been expanding his world and inspiring the origi-nal compositions that make up his celebrated "Earth Music" albums. When The Greenwich Workshop invited Paul Winter to create a com-panion album for Bev Doolittle's painting *Prayer for the Wild Things*, both artist and musician were thrilled. Bev wrote, "I love this concept. I've always had this dream, this fantasy of putting music and art together."

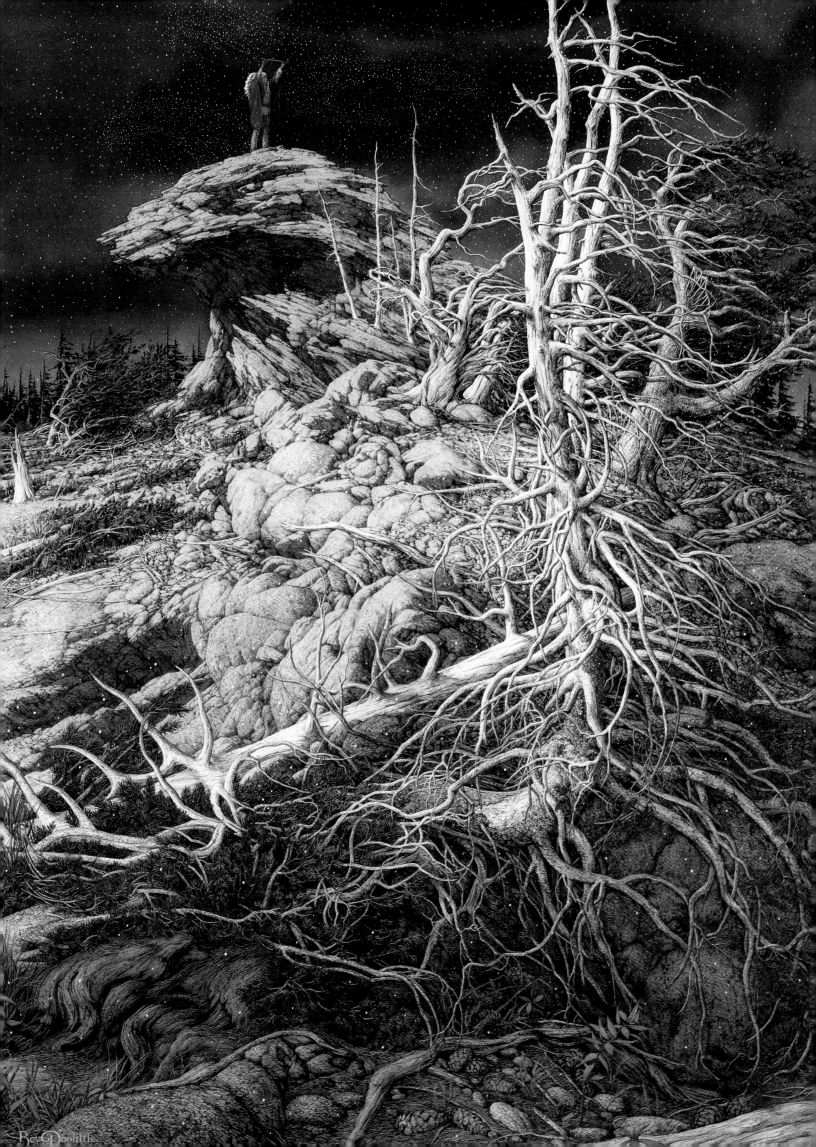

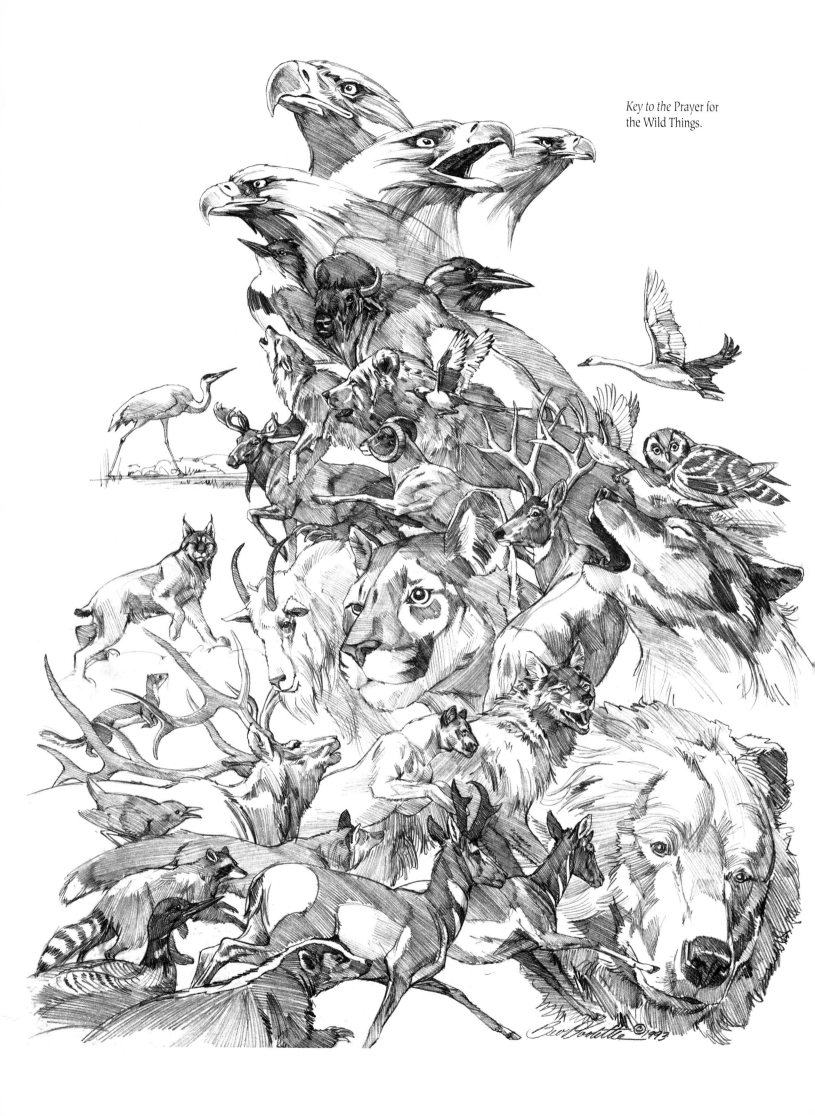

*Key to the* Prayer for the Wild Things.

"For years," Paul Winter told her, "one of my goals has been to create 'sound paintings' celebrating the beauty and spirit of animals in the wild. I've always used sound as a starting point. To do it with a painting as the point of departure is a whole new adventure for me."

To create his "sound painting" Paul Winter traveled from Yellowstone National Park, to Glacier National Park, to the Grand Tetons. His journal records one memorable experience in an echo-filled canyon called Gates of the Rocky Mountains on the Missouri River, north of Helena, Montana. "I played from a narrow beach between thousand-foot cliffs, the territory of bald eagles, kingfishers, ospreys and ravens that tumbled in and out of their lofty nooks. I was playing this piece with my eyes closed, unaware of the Canada geese floating

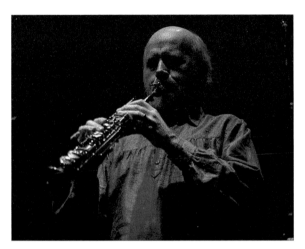

downriver towards me. When they exploded into flight I was so startled I stopped playing, but was glad then to let them finish the music as they circled back in full chorus, heading south toward the buffalo prairie."

Bev, who was there at the time, was fascinated with the echo. She says, "It seemed as if the response was the earth joining in, participating and helping us celebrate the beauty."

Back in his barn studio, Paul decided that the album's theme would be an imaginary journey through a day and night in the northern Rockies. He composed a series of musical vignettes inspired by the region's wildlife.

*Paul Winter (left).*

[79]

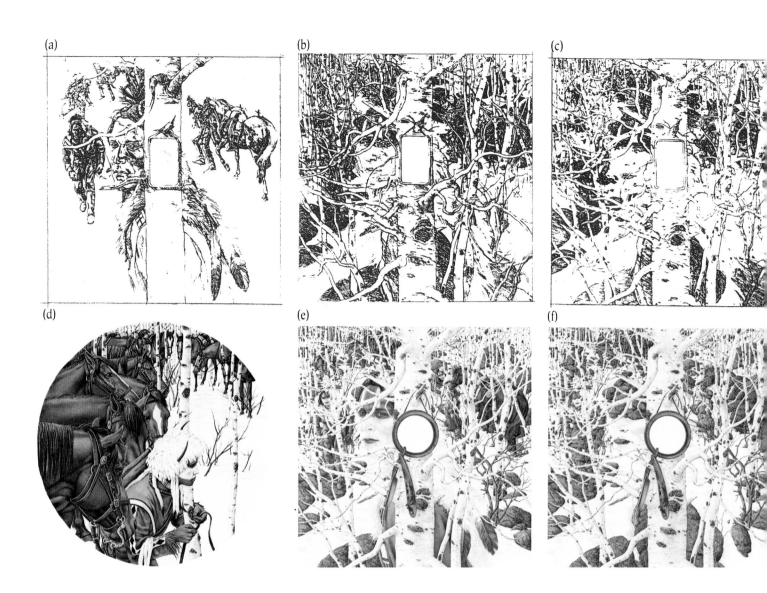

(a) (b) (c) (d) (e) (f)

*Steps in the creation of* Two More Indian Horses, *a combination of original art and the cutting edge of print technology, in which two stealthy warriors pay a visit to a U.S. Calvary camp and make off with two of the soldiers' horses. The first sketch (a) shows the placement of the two warriors throughout the entire print series. In the second (b), the forest has been drawn in around them. The third sketch shows how the forest will appear with the warriors "camouflaged out" (c). The story is told not only in the main body of the print, but in the mirror's reflection as well. A painting was created for the mirror used in each panel (example, d), three in all. Then an original was created, first with the warriors "in" (e) and then "camouflaged out" (f). All the elements were then combined digitally in the printing process to create the final set of images (following page), in which the two warriors approach the camp (1); as one watches, the other "liberates" two calvary horses (2); and then the two successfully sneak away (3).*

# TWO MORE INDIAN HORSES

He began by selecting the instruments to represent various animals, and for each pair Winter wrote a short theme. "Animals don't usually sing long melodies; they sing short phrases." The cello is the grizzly; the wolf, the soprano sax; the mountain lion, the bassoon. Because bull elk bugle, by forcing wind up through their throats—producing overtones similar those that brass players create with their instuments—they would be portrayed by French horns.

When Bev Doolittle's painting was released in limited edition fine art print form, each was accompanied by a compact disc of Paul Winter's *Prayer for the Wild Things* album. Mingling jazz, classical, sacred and Native American music with the sounds and songs of nature, the album features Paul Winter, the Earth Band, Arlie Neskahi and the White Eagle singers, and the voices of 27 birds and mammals of the Rocky Mountains. In 1995, Paul Winter's *Prayer for the Wild Things* album was nominated for and won a Grammy award.

Fame and fortune can, of course, be as lethal as it is heady for an artist, but Bev Doolittle appears remarkably unchanged by her celebrity status. As a young artist,

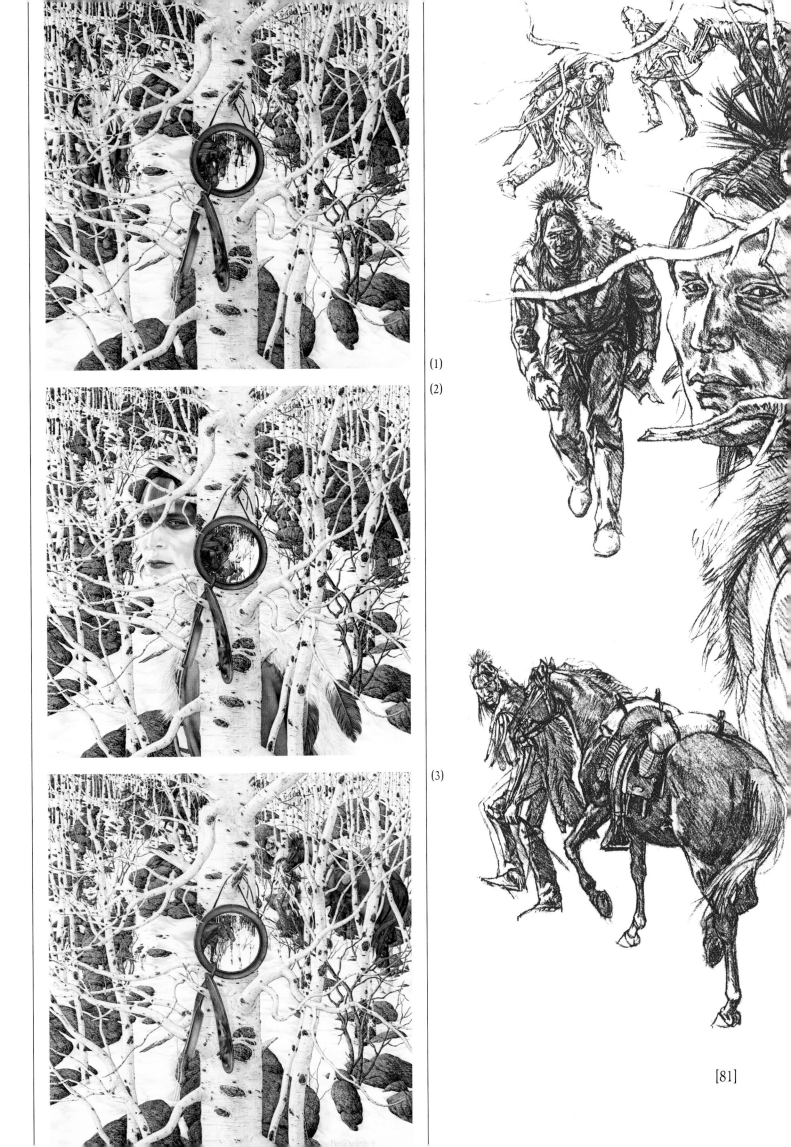

(1)

(2)

(3)

[81]

BEV DOOLITTLE © '92

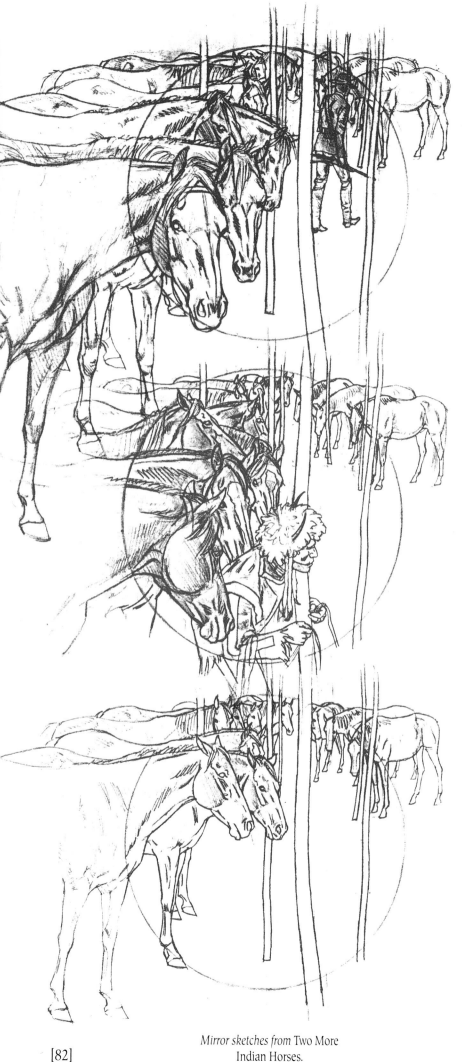

*Mirror sketches from* Two More
Indian Horses.

just starting out, she would have been thrilled to get a letter from an important general. She still is. She would have found time to answer a child's letter. She still does.

When she was a "starving artist," living and working in a camper-van, Bev Doolittle wished to do really significant things for conservation education, wildlife and wilderness habitat preservation. Now she does. An arrangement with her art publisher sees to it that a portion of the proceeds from her prints is donated to causes she believes in. Nearly a million dollars has been raised in this

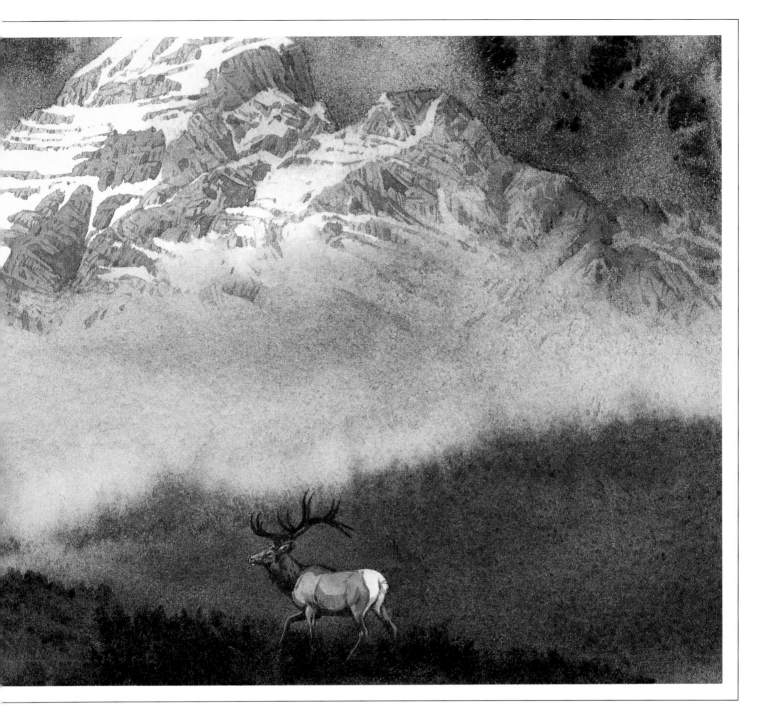

way. Fourteen institutions, foundations and wilderness sanctuaries have benefited. But her unique contribution is her ability to create art that touches the heart and inspires others to treat the earth more kindly.

Marveling at the number of new creative efforts Bev was getting involved in, a friend asked, "Can you afford it?" Bev knew that her friend was talking about more than money. She was talking about Bev's new creative directions, the risk in doing so, abandoning the security of prior success and getting involved in projects other than those people expect her to create.

It's a subject Bev has given a good deal of thought to,

# HOLE IN THE CLOUDS

acting decisively on it almost 20 years ago when she and her husband left secure careers in an advertising agency, determined to earn a living, no matter how meager or precarious, as fine artists.

Still, Bev pondered her friend's question and finally

gave her a short answer and a long one. Could she afford to try new things? The short answer was "I can't afford not to."

The long answer was a book, *The Artist's Way* by Julia Cameron. When Bev came across it, she had been astonished to find that it mirrored her heart. She highlighted a section entitled "Success."

*Creativity…is not something that can be perfected, finished, and set aside…we reach plateaus of creative attainment only to have a certain restlessness set in.*

*In other words, just when we get there, there disappears. Dissatisfied with our accomplishments, however lofty, we are once again confronted with our creative self…what are we going to do…now?*

*This unfinished quality, this restless appetite for further exploration, tests us. We are asked to expand in order that we not contract. Evading this commitment…leads straight to stagnation, discontent, spiritual discomfort. "Can't I rest?" we wonder.*

*In a word, the answer is no.*

With so many exciting ideas out there, Bev Doolittle can think of nothing more wonderful than being able to explore them.

"Isn't it scary?" her friend asks.

Yes, Bev says, but so was that time in Alaska when she and Jay got out of a small plane and watched the bush pilot take off, leaving them alone to run a wild stretch of the Alatna River above the Arctic Circle. And that was one of the most thrilling adventures of her life.

Peak experiences, she says, are always scary, and for her the creative process has always been a peak experience. She wants to keep it that way.

Some results of her experimentation are already tangible. *When the Wind Had Wings*, a mystic meld of painting and poetry; *Prayer for the Wild Things*, an innovative collaboration that confers the ability to see music and hear a painting; *Two More Indian Horses*, a triptych in which the artist and printer together create an original work that combines art and 20th-century technology. The format Bev Doolittle devised and the storytelling element she wanted to build in required her to paint in stages and supervise the digital computer assembly of multiple images. The result represents something quite new in the print industry. It's also

typically Bev. With her usual joyful curiosity and little previous experience, she welcomed what many would consider a daunting learning experience and took a flying leap onto a high-tech magic carpet.

"There are a million things an artist can do with this new and fascinating medium," she muses. But at the moment, what she is most excited about is an expedition into yet another new world—the world of fiction.

Bev and Jay Doolittle have embarked on a collaborative book project with writer Elise Maclay. It's an adventure story, a hide-and-seek chase and an interactive mystery—with Bev's paintings supplying the clues the reader will use to solve the puzzle. The book will provide for the imaginative reader a glimpse of the artist as a child, already committed to beliefs that consistently illuminate her life and art. The title she has chosen for it is telling: *The Earth Is My Mother*.

What will she do next? Bev Doolittle laughs and says, "I can't wait to see." After all, integral to magic is the element of surprise.

# ACKNOWLEDGMENTS

The author and publisher have made every effort to secure proper copyright information for works cited in this book. In the event of inadvertent error, the publisher will be happy to correct it in subsequent printings.

The Greenwich Workshop extends grateful thanks for material that appears by permission of the following: From *A Sand County Almanac, with Other Essays on Conservation from Round River* by Aldo Leopold. Copyright © 1949, 1953, 1966, renewed 1977, 1981 by Oxford University Press, Inc.; Alfred Knopf, Inc., for quote p. 30 by Paul Gallico from *The Snow Goose*, copyright 1940 by Curtis Publishing Company, copyright renewed 1968 by Paul Gallico, reprinted with permission of Alfred Knopf, Inc.; John Varley for quotes pp. 44, 45; Yellowstone Grizzly Foundation for quote p. 46; Steve French for quote p. 48; Marilyn French for quote p. 48; Wolf Haven International for quote p. 51 from "The Wonder of Wolves"; Ed Clark for quote p. 52; Tom Munds for photo of Bev Doolittle with wolf p. 53; Marcellus Bear Heart Williams for quotes pp. 58–59, 60, 62; Chief Dan George for quote p. 60; Jonathan Felt for paraphrases pp. 62–64; Paul Winter for quote p. 79 and quotes from his journal pp. 79–80; The Putnam Publishing Group/ Jeremy P. Tarcher, Inc., for quote p. 84 by Julia Cameron from *The Artist's Way*, copyright © 1992 by Julia Cameron, reprinted by permission of the Putman Publishing Group/ Jeremy P. Tarcher, Inc.

"Sacred Circle" is a registered trademark of The Greenwich Workshop.

## LIST OF PAINTINGS

## LIST OF POETRY